The Inauguration of
BARACK OBAMA

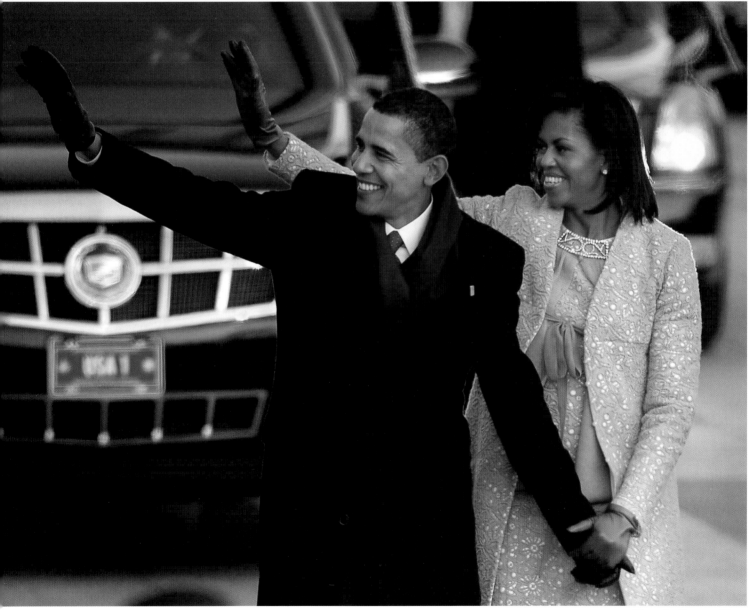

Photo by Preston Keres

The Washington Post

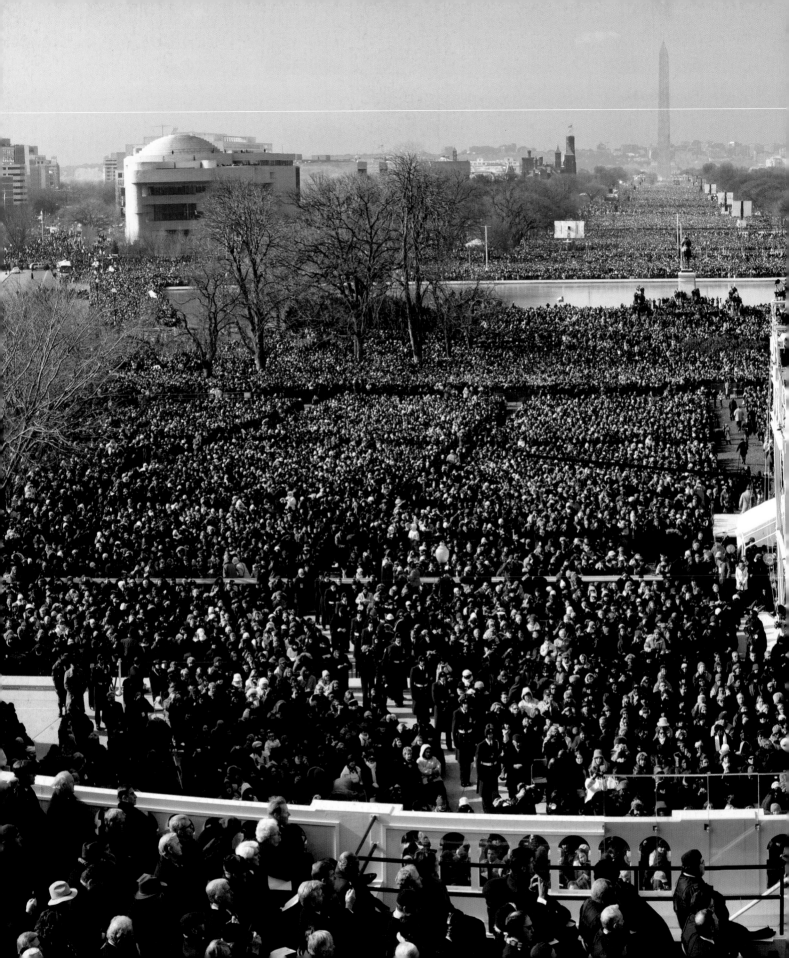

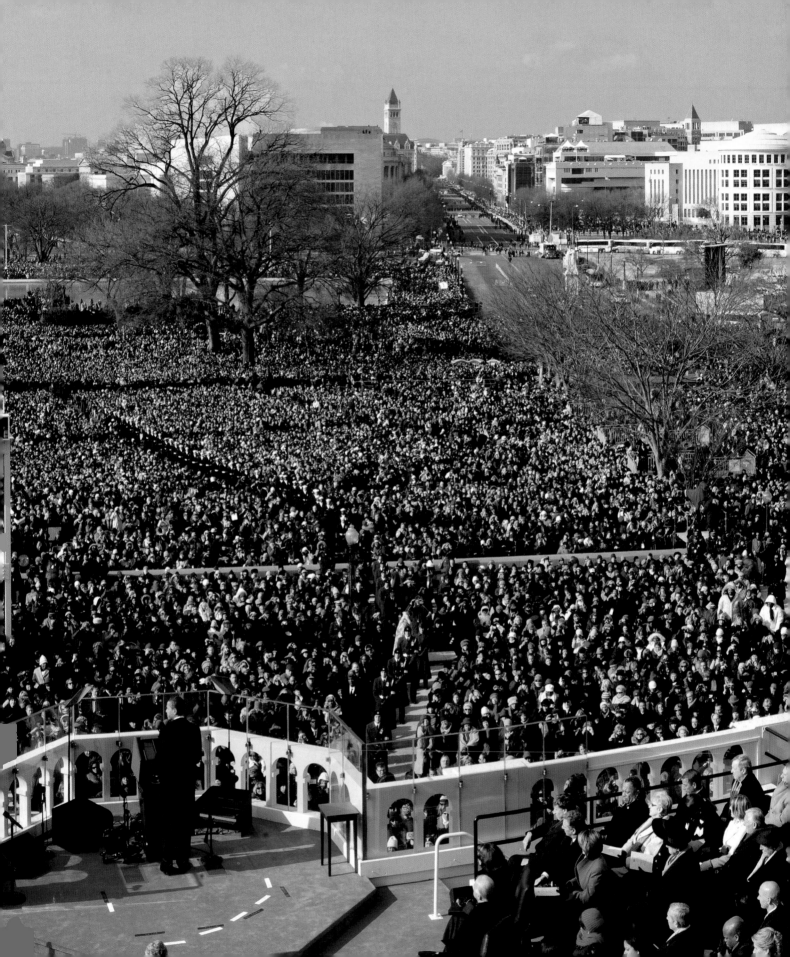

Triumph Books and colophon are registered
trademarks of Random House, Inc.

This book is available in quantity at special
discounts for your group or organization. For
further information, contact:

TRIUMPH BOOKS
542 S. Dearborn Street, Suite 750
Chicago, IL 60605
Phone: (312) 939-3330
Fax: (312) 663-3557

ISBN: 978-1-60078-284-8
Printed in U.S.A.

Produced by *The Washington Post*

Book Editor: Mary Hadar

Photo Editors: Bonnie Jo Mount, Michel du Cille

Art Director: Jon Wile

Assistant Editors: Jill Drew, Ellen Edwards

Design Consultants: Janet Michaud, Justin Ferrell, Tan Ly,
Dennis Brack, Greg Manifold

Copy Editor: Mike Stuntz

Contributors: Perry Bacon, Jr., DeNeen L. Brown, Carrie Camillo, Aaron C. Davis,
Dan Eggen, Julia Ewan, Michael A. Fletcher, Robin Givhan, Hamil R. Harris, Steve
Hendrix, Susan Kinzie, Anne E. Kornblut, Richard Leiby, Debra Lindsey, Melissa
Maltby, David Maraniss, Melissa McCullough, Mark Miller, Robert Miller, Jonathan
Mummolo, David Nakamura, Giuliana Nakashima, Robert E. Pierre, Michael E.
Ruane, Eli Saslow, Ray K. Saunders, Michael D. Shear, Nikita Stewart, Lena H. Sun,
Wendy Galietta Williams

Previous page photo by Bill O'Leary

Contents

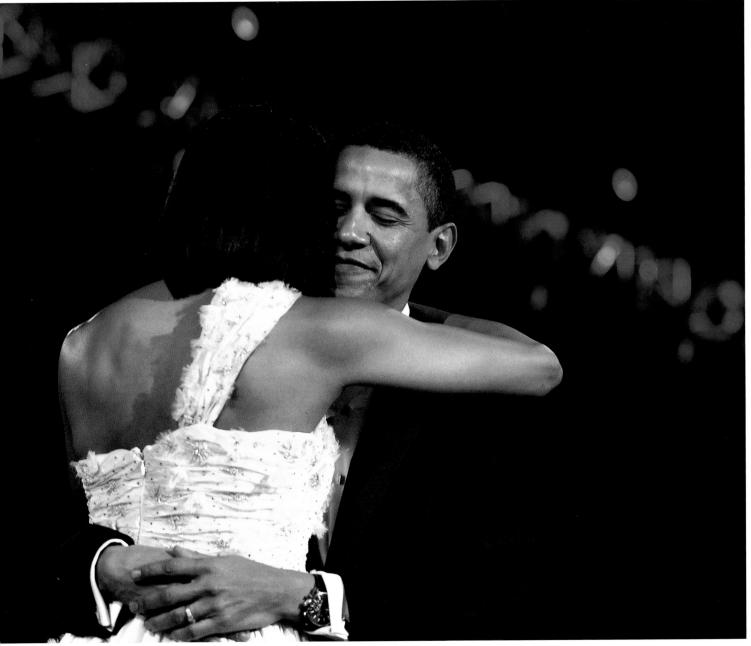

Photo by Richard A. Lipski

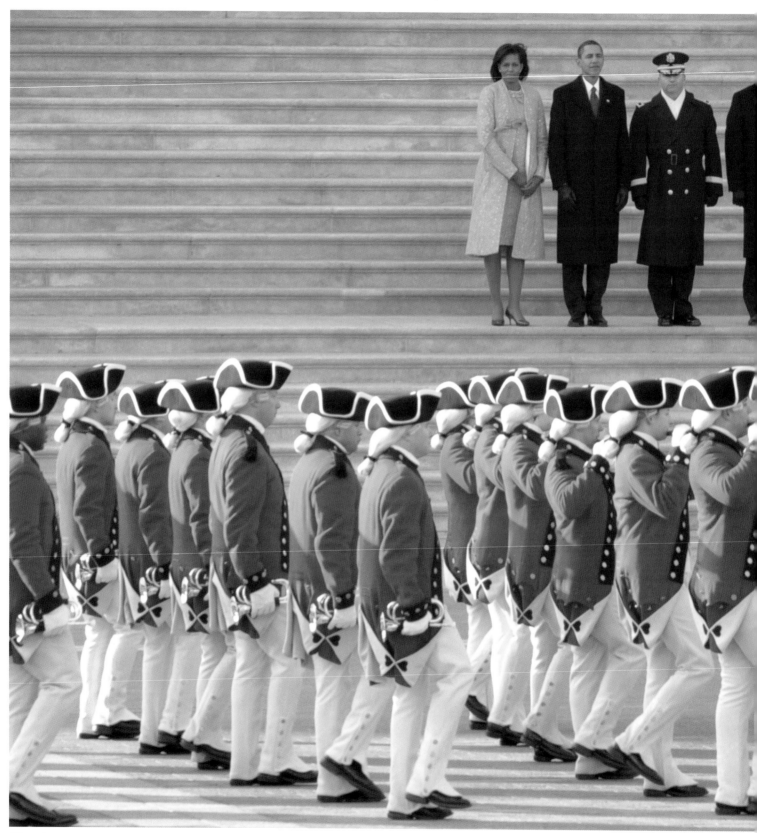

Photo by Marvin Joseph

Foreword

One of the glorious things about Washington is that it changes every four years. It's like the tide going out, and a new one coming in, with new ideas, a new cast of characters and a remarkable excitement about the new leader. The enthusiasm now about Barack Obama brings to mind another inauguration, the first one I attended — for John F. Kennedy.

I can hear him now. That familiar voice — curiously high-pitched in the freezing sunshine — "Ask not what your country can do for you . . ."

We weren't going to ask him anything. It was too damn cold — 22 degrees with almost eight inches of powder snow on the benches lined up in front of the Capitol.

More than the weather went wrong that morning, Jan. 20, 1961. The sun reflecting off the snow was so bright that Robert Frost could not read the "preface" that he had prepared for the occasion. After several false starts, he was heard to say, "I can't see in the sun," and he finally gave up and began to recite his poem, for which he needed no manuscript.

Who cared about the snow, the stiff wind, the blinding light? The occasion surmounted all difficulties.

Kennedy, 43, was the first president born in the 20th century, the youngest elected president. That seemed remarkable to us, but not so dramatic as Barack Obama's ascendance as the first African American president is now.

This shift of power is orderly, but it's always exciting. It's the essence of democracy. We give the president great power knowing that in a few years he will surrender it gracefully.

By that time, his people have become part of the fabric of the city. Even if the president leaves town when his time is up, much of his administration stays here and joins the rest of us who are absorbed by the fascinating business of government.

Barack and Michelle Obama don't know it yet, but they are going to be changed by their experience just as they change the city that will be their home for the next few years.

— *BEN BRADLEE, Washington Post Editor-at-Large*

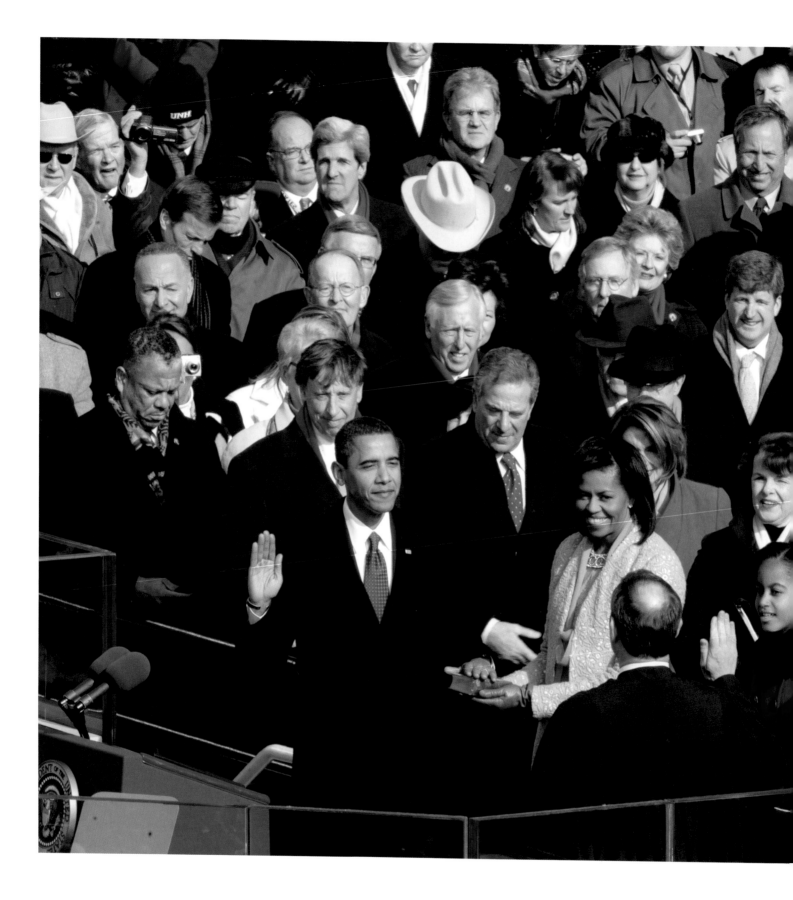

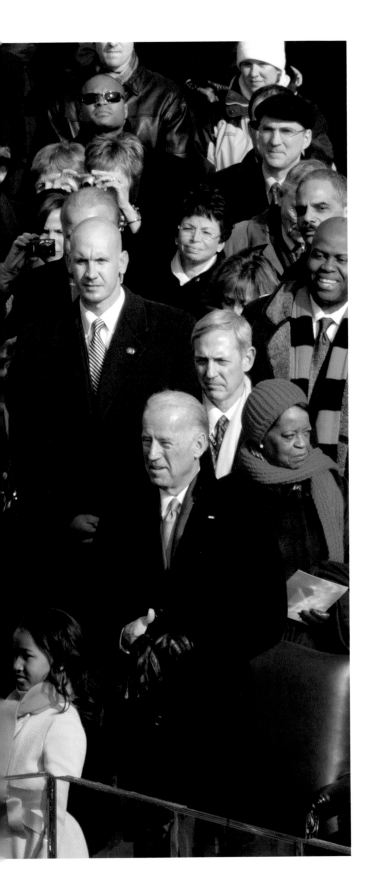

Improbable Path
To a Historic Moment

Barack Obama saw his future home for the first time a quarter-century ago. He was a year out of Columbia, working in Harlem as a community organizer, when he rode to Washington with a scrum of college undergraduates protesting proposed cuts in student aid. After a long day on Capitol Hill, they walked west along the National Mall, then circled around to Pennsylvania Avenue and paused in front of the White House. Beyond the fence, past the northwest gate, lived Ronald Reagan, the 40th president of the United States.

Ambitious political thoughts would enter the young traveler's mind soon enough, but not yet. The year was 1984. Obama, a study of cool on the outside, burned inwardly with what he once described in young black men as a "knotted, howling assertion of self." At age 22, he was just emerging from a few lonely years in New York, a lost period that he has revealed least about in his memoirs. He had not yet figured out the life's course that would take him from then to the historic day, Jan. 20, 2009, when he would enter that same White House to live and work as President Obama, occupant No. 44.

There is improbability in the making of any president, some more than others, none comparable to Barack Obama. From Lincoln to Truman to Clinton, the cast of American presidents who came out of nowhere, with no connections, is as conspicuous as the well-born lineage of Adams and Roosevelt and Bush. And there were some intimations of fame, real or imagined, along the way with Obama, dating to his toddler days in Honolulu when his grandfather told camera-toting tourists that the chubby, tan little boy at his side was the progeny of a great Hawaiian king. In later years, men of a more serious mien, from the constitutional law professor Laurence

Photo by Toni L. Sandys

Tribe at Harvard to the federal judge Abner Mikva in Chicago, were sufficiently impressed to proclaim that young Obama had the wherewithal to become the first black president.

But it is common to find bits of predictive bread along the trail of a prominent life when retracing it. Who knows how many sure-bet future national leaders have slid instead into anonymous careers? In the 47 years since he was born in Hawaii to a white teenage mother and a black African father, as distant from the White House figuratively and physically as it is possible to get in the United States, the Obama story has unfolded as a triptych of the unlikely. The biography of his family, the sociology of his skin color and the geography of his political rise — these three panels of his story combined to make the end result all the more vivid, if implausible.

The first president to enter the White House with a literate and introspective memoir behind him, Obama is his own book of firsts. He is the first president with a foreign father. He is the first president to grow up in Hawaii, the 50th state. He is the first president to have set foot on the American mainland for only two brief visits before arriving on the West Coast for college. He is the first president whose parents earned doctoral degrees. He is the first president who once could speak the Indonesian language. He is the first president who was president of the Harvard Law Review. He is the first president who was a hapa, as they are called in Hawaii, with parents of different races. He is the first president who has a sister from Asia and a sister from Africa and a wife from the black working-class South Side of Chicago. And he is the first African American president, yet one with no slaves but a few slaveholders in his ancestry.

Obama is the creation of restlessness, searching, odd connections. He springs out of this wide world, defined by disparate locations that together enfold many of the central themes and movements of modern times.

His father comes out of Kenya as it struggles through anticolonialism toward freedom and the promise and disappointments of a new Africa. His mother comes out of a Seattle suburb at a time when education and global optimism are the twin gods of postwar America's liberal middle class. His parents connect briefly in remote Hawaii,

where East meets West, the world's future in redefining race. His mother becomes obsessed with Indonesia, the most populous Muslim country in the world, a vibrant and dangerous clash of old and new cultures, testing the rights of women and of individuals in an authoritarian state. Obama grows up without a father and often apart from his mother, wrestling with feelings of abandonment at the same time that he tries to resolve perplexing questions of race and identity. After attending Honolulu's elite prep school, he leaves the faraway island for the cosmopolitan areas of Los Angeles, New York and Boston before settling in Chicago, building a family, a network of close friends, and a political life in a city that has served as a social and cultural haven for so many black Americans who migrated there before him.

The traits that might define President Obama arise from this history: his blend of idealism and pragmatism, his intellectualism and ego, his calm aggressiveness and seeming lack of neediness, his determination not to be boxed in, his open-minded guardedness and aversion to naiveté, his capacity to view himself from outside as a character in his own story, alternately dramatic and ironic. Coming of age as a self-described "mutt like me," as he said at the first news conference after his election, at once set him apart, making his journey often a lonely one, while also making him seem accessible to the world.

It is a modern-day version of the classical odyssey, leaving home for a long journey in search of home. In his memoir, Obama's curiosity takes him back to the place that was least familiar to him in his childhood, to his father's roots in the village of Alego in the central Nyanza District in the country of Kenya. The African story is so exotic — the sights, smells and tangle of relationships with various relatives from different marriages — that it tends to crowd out the other side of the story, which has its own measure of color and racial symbolism. This is the turf of his white grandfather: the town of El Dorado in the county of Butler in the state of Kansas.

There is more than a touch of incongruity in the fact that the county where Obama's grandparents grew up is named for a slaveholding senator from South Carolina, Andrew Pickens Butler, who was one of the leading proponents of making Kansas a slaveholding state as a

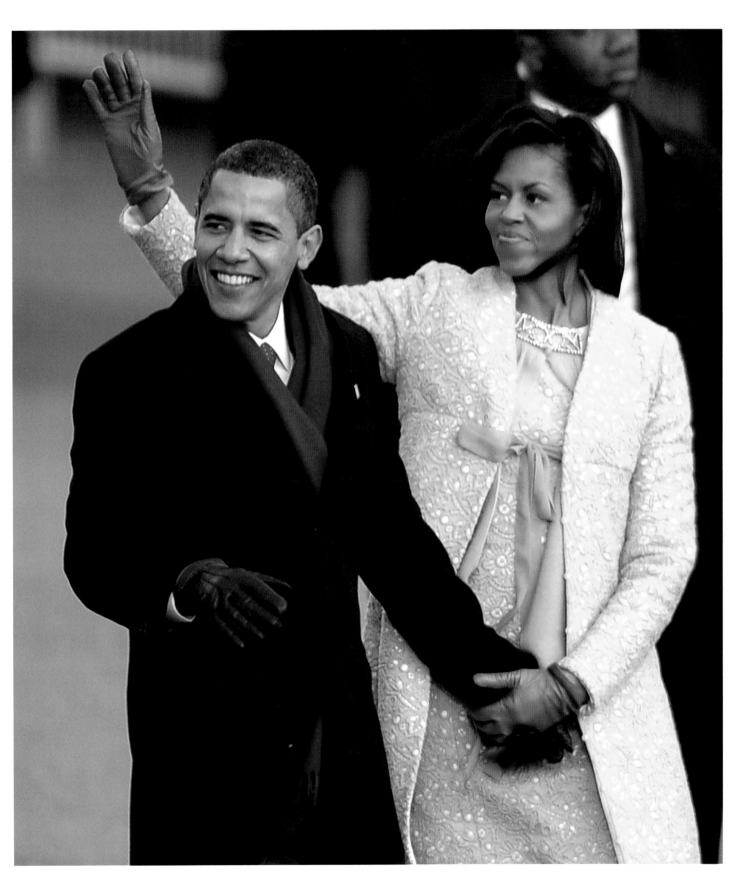

Photo by John McDonnell

sponsor of the 1854 Kansas-Nebraska Act. But then again, slaves are part of the family story. Old Violet. Young Violet. Nancy. Peggy. Little William. Moriah. Sarah. Caty. Susannah. Selah. Isaac. According to documents analyzed by the expert genealogist William Addams Reitwiesner, these are the names of slaves Obama's white ancestors owned in the first half of the 19th century, in Virginia and Kentucky, before the families moved west to Kansas.

El Dorado, the county seat of Butler County, was home to Stanley Armour Dunham, Obama's grandfather, whose distinct facial features were passed along to his grandson. "El dorado" is Spanish for "the gilded one," or golden one, and represents the mythological city of wealth long sought by Spanish explorers. The El Dorado of Kansas, pronounced el-duh-RAY-dough, was gilded in oil during Stan Dunham's early years. The El Dorado oilfield started gushing a few miles east of town in 1915, three years before Dunham was born, and throughout the 1920s, Butler County was enriched by an oil boom, transformed into a jumble of derricks, pipelines and refineries that briefly made Kansas the third-leading oil producing state in the country.

From El Dorado to President Obama in two generations — but Stan Dunham was not a golden one. Family lore, passed along by Obama in his memoir, is that Stanley's mother, Ruth Lucille Armour Dunham, committed suicide in 1926, when he was eight years old. Contemporaneous obituaries say that she died of ptomaine poisoning late one November night. In any case, young Stanley, who went to live with relatives rather than his rejecting father, became unsettled and footloose. He punched a teacher at El Dorado High and did not graduate with his class, but a year later. He did have some of the charisma of his grandson, it appears, enough to get the studious Madelyn Lee Payne to marry him, secretly, several weeks before her high school graduation.

The Paynes came from Augusta, 15 miles down the road from its rival El Dorado. Madelyn's father was an oilman, a clerk for a pipeline company, and the family lived on the rim of town in a company house on company land with oil pipes stacked high in a field behind their back yard. Madelyn started dating Stan Dunham, who was four years older, during her senior year after meeting him in Wichita,

probably at the Blue Moon dance pavilion. One night that spring of 1940, at a slumber party with 11 friends at Nina June Swan's downtown apartment above LoVolette's China and Gifts, she shocked them all by letting on that she had secretly wed Stan earlier in May on the night of the junior-senior prom.

Madelyn's friends were not impressed by her catch. They thought Stan was full of himself, a fast-talking showoff with what one called "a superior attitude." In the first days of married life, Madelyn lived at home with her parents and two younger siblings until school let out, hiding the secret. Her father, Rolla Payne, was less than happy when he finally got the news. Stan had slicked-back hair and darker skin than most people in Butler County, and though he was not Italian, there were many Italians who came to Kansas to work in the mines over near the Missouri border. Old man Payne is said to have called his son-in-law "that wop."

In two years, Stanley Ann Dunham, Obama's mother, was born.

In the unlikely saga of Barack Obama, history would repeat itself, in a way, a generation later. Stan, a salesman with what Madelyn called "itchy feet," had taken the family to California, Oklahoma, Texas, back to El Dorado and on to Mercer Island in suburban Seattle before finally migrating farther west for a final stop in Honolulu. And here came their daughter, Stanley Ann, the same age that Madelyn was when she secretly married Stan, befriending an older man with darker skin, a student from Africa named Barack Obama, getting pregnant by him, marrying him in private, and bearing a single child by him, a son. "Ever see the movie 'Guess Who's Coming to Dinner'?" Stan would later ask Rolf Nordahl, a friend and colleague at the John Hancock Insurance Co. office. "Well, I lived it."

The theme of that movie, white parents dealing with the idea of their daughter marrying a black man, seems anachronistic now, but it was a different world then. When Stanley Ann Dunham married Barack Hussein Obama in February 1961, the union of a white woman and a black Kenyan man was still illegal, breaking anti-miscegenation laws in Alabama, Arizona, Arkansas, Delaware, Florida, Georgia, Kentucky, Louisiana,

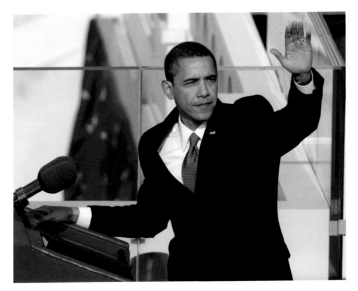

Photo by Jonathan Newton

Maryland, Mississippi, Missouri, Nebraska, North Carolina, Oklahoma, South Carolina, Tennessee, Texas, Utah, Virginia, Wyoming and West Virginia.

The racial distance the nation had to travel to reach the inauguration of President Obama can be measured by what was going on in America on the day of his birth. He was born on Aug. 4, 1961. In Shreveport, La., that day, a squadron of policemen assembled inside the Continental Trailways bus depot to uphold local and state laws prohibiting black people from stepping foot in a waiting room reserved for whites. Four African Americans had arrived at the depot with tickets to take the morning bus from Shreveport to Jackson, Miss., the hub of protests where hundreds of freedom riders had been arrested in previous months. When they attempted to enter the white waiting room, they were met by the Shreveport police chief and 40 officers. The riders refused orders to leave and were arrested for disturbing the peace.

On that same day in Washington, five African Americans who had been arrested by security police for trying to integrate the Glen Echo Amusement Park in the Maryland suburbs were asking the U.S. Supreme Court to review the case. And in Alabama and Mississippi, an early voting rights battle was waged, with lawsuits filed in three counties where voting officials imposed prohibitively rigid standards on black applicants. In one county in

Mississippi, there were 2,490 blacks — and none was registered to vote.

Four years later, President Lyndon B. Johnson urged a joint session of Congress to pass legislation that would remove every barrier discriminating against blacks and their right to vote. "Their cause must be our cause, too," Johnson said. "And we . . . shall . . . overcome." The National Voting Rights Act of 1965 moved swiftly through Congress, with the Senate giving final approval to the conference report — on Aug. 4, Barack Obama's fourth birthday. "We've lost the South for a generation," Johnson told Bill Moyers, his aide, after he signed the measure two days later. Perhaps so, as it turned out, but without Johnson and voting rights, the inauguration of Obama as the 44th president may not have been possible 44 years later.

It is said that history moves in 20-year cycles, and that fits with the chronology of Obama and race. On the evening of April 4, 1968, the Rev. Martin Luther King Jr. was assassinated as he stood on the balcony outside his room at the Lorraine Motel in Memphis. One of the young aides who witnessed the murder was Jesse Jackson, then 26, who ran the Southern Christian Leadership Conference office in the northern outpost of Chicago. Jackson flew home the next day and appeared at a memorial session of the Chicago City Council still wearing the shirt he had worn the day before. "I come here with a heavy heart, because on my chest is the stain of blood from Dr. King's head," Jackson said. "He went through, literally, a crucifixion. I was there. And I'll be there for the resurrection."

Twenty years later, in 1988, Jackson sought the Democratic presidential nomination for a second time. He received nearly 7 million votes. And 20 years after that, there was the same Jesse Jackson, back in Chicago, standing in the crowd on election night 2008, tears streaming down his cheeks, as he watched Barack Obama step onto the stage as the next president of the United States. Human interaction is never as uncomplicated as the symbolism, Jackson did not always accept Obama's rise without envy, but here, it seemed, was the political resurrection that he had long ago foreshadowed.

But of course the coming of this black president was not preordained. By the time Obama entered elective

politics in 1996, he had channeled his inward churning into a strong-willed ambition to reach the White House, a political explorer in determined search of his el dorado. He had prepared at Harvard Law School and returned to Chicago with something that golden in mind. Still, there was an uncommon amount of luck along with skill that propelled him on the path that brought him to implausible day.

He might not have been elected to the Illinois state Senate in 1996 if Alice Palmer, the incumbent from his South Side district, had not been sidetracked by an unsuccessful bid for a congressional seat and had not failed to round up the required number of signatures when she petitioned to get back in the race. That was good fortune; Obama deciding to challenge her petitions was competitive will. He probably would not have been elected to the U.S. Senate eight years later if not for the collapses of two opponents, first the demise in the primary campaign of Democrat Blair Hull when it was revealed that he had beaten his former wife, then the implosion of Republican Jack Ryan after divorce records detailed his fondness for sex clubs. That was all luck; Obama deciding to run in the first place, after losing a congressional primary in 2000 and feeling the increasing impatience of his wife, Michelle, who would grant his political obsession only one last chance — that was burning will.

It was luck for Obama to be chosen to deliver the keynote address at the 2004 Democratic National Convention at a time when he was virtually unknown outside his home state. It was outsize confidence that led him to boast to friends as he walked to Boston's Fleet Center that pivotal day, as recounted by Chicago writer David Mendell, that he was as cool and self-assured as LeBron James and would nail the speech just like the NBA star would nail a game-winning shot. He was lucky that Hillary Rodham Clinton's presidential campaign was overconfident and believed the primary contest would be over by February last year, but it was skill and will for Obama and his team to prepare for the long slog and organize in caucus states that the formidable Clinton ignored. That same cycle of luck would be repeated over and over until the historic Election Day in November.

Many times during the dozen years of Obama's political rise he appeared destined only for obscurity. The afternoon in 1998 when he spoke to an audience of seven people at a brightly lit ice cream parlor on the southern rim of Chicago, sitting on a wooden stool, relaxed with legs crossed, patiently going through an early version of a stump speech about hope and racial reconciliation that later would become his trademark. The summer of 2000 when he flew from Chicago to Los Angeles for the Democratic convention and no one knew him and his credit card bounced and he left after a forlorn day hanging out as an unimportant face lost in the power-lusting crowd. The January evening in 2003 when he began his U.S. Senate campaign by driving up from Springfield to Rockford for a banquet honoring black and Hispanic professionals and was barely recognized, sitting at a back table as a motivational speaker droned on.

Mike Jordan, an insurance agent from suburban Chicago and a longtime associate, was with Obama that night in Rockford, and worried that the candidate would be depressed afterward, or so in need of political affirmation that he would work the crowd for every hand he could possibly shake on the way out the door. Instead, Obama went off to a corner to talk to the 15 or so young people who had been awarded minority scholarships, thanking each of them, listening to their stories. No need to panic, Obama told his staff on the way out. No one knew us, okay, but let's see what happens.

The essence of Barack Obama has been his capacity to avert life's roadblocks and disappointments during his journey. The first could have been his unusual family biography, with the challenges it presented in terms of stability and psychology. The second could have been the sociology of race in America, with its likelihood of rejection and cynicism. And the final was the geography of elective politics, with all the variables of ideology and luck. In each case, Obama kept moving, finding his way around dead ends, avoiding the traps. A quarter-century after his first glimpse of the White House, he retraced the route from the U.S. Capitol west along Pennsylvania Avenue, this time ensconced in the back of a presidential limousine, the whole world watching, as he glided toward his new home.

—*DAVID MARANISS, Washington Post Associate Editor*

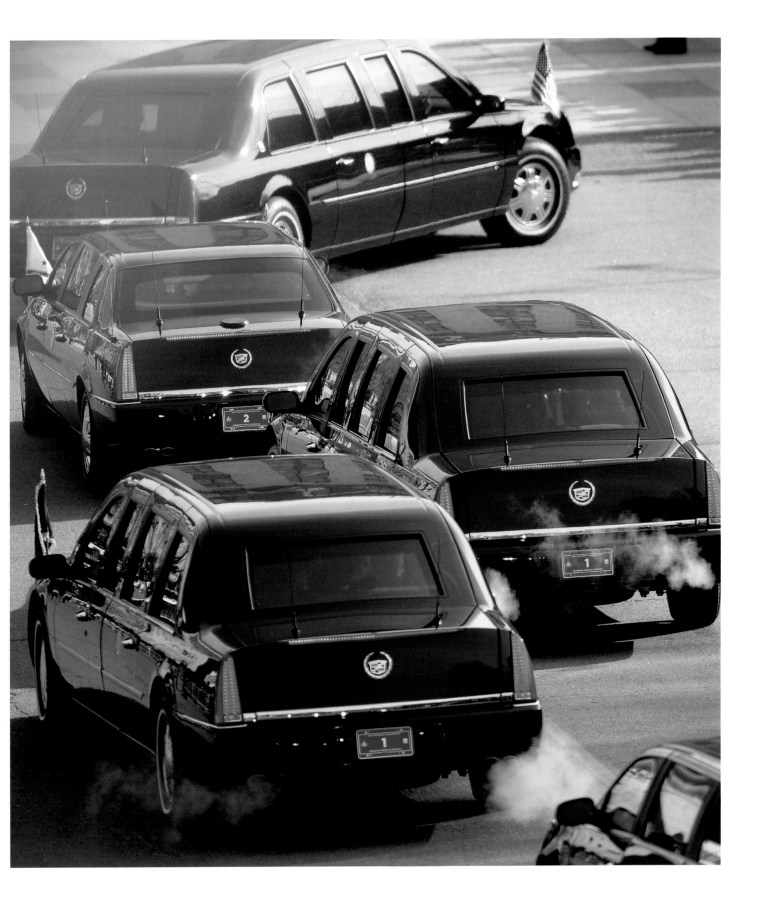

Photo by John McDonnell

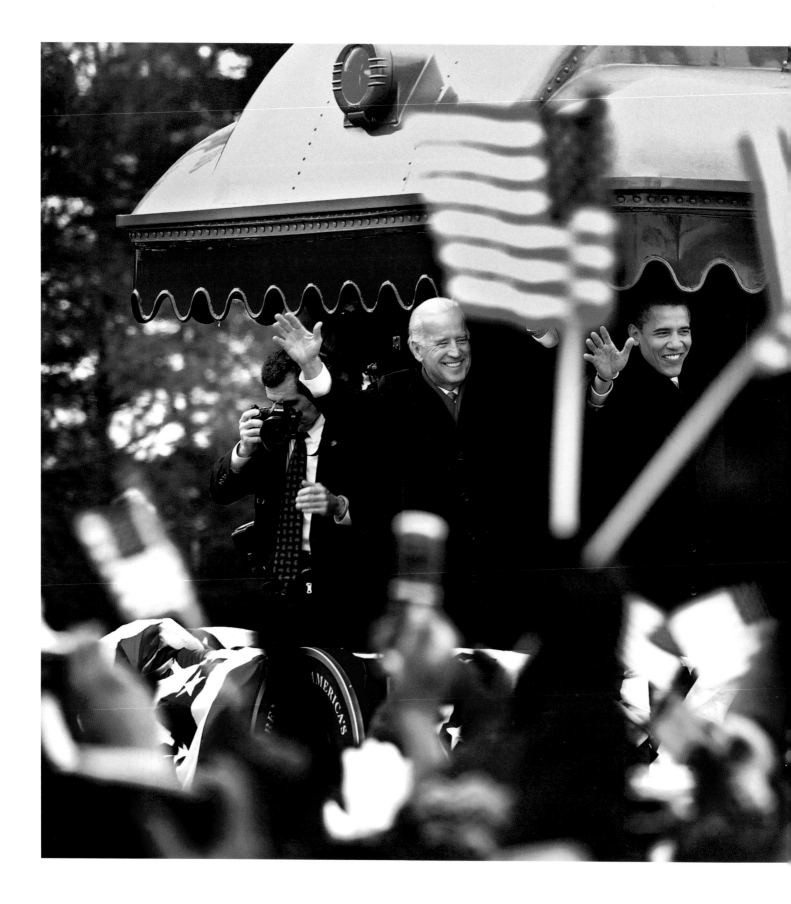

Destination: Washington, D.C.

SATURDAY, JANUARY 17

The inaugural weekend began with a train trip, as Barack Obama retraced the path Abraham Lincoln took to his inaugural celebration in 1861. Obama started in Philadelphia, where the Founding Fathers laid the groundwork that would make this journey possible so many years later.

With family, friends and advisers, Obama traveled for six and a half hours in the 1930s-era blue car on a slow-rolling whistle-stop trip to Washington. He began in Philadelphia with a rousing speech, looking back at the visionaries who created the Declaration of Independence and the Constitution. In Wilmington, Del., there were more speeches and a welcome for Joseph R. Biden Jr. and his family as they joined the travelers. In Baltimore, Md., 40,000 people filled the War Memorial Plaza, hugging, cheering and clapping. And three times, the train slowed as Obama stepped out on the rear platform to blow the whistle and wave to the crowds.

Everywhere along the tracks, the people of America waited. Bundled in winter jackets, they gathered along highway overpasses, icy lakes, Little League baseball fields, cow pastures and neighborhood cul-de-sacs. Firefighters stood on their trucks to take pictures; schoolchildren held handmade signs.

Barack Obama was riding the rails to history.

Obama and Biden pass through Edgewood, Md., on their way to Washington.

Photo by Preston Keres

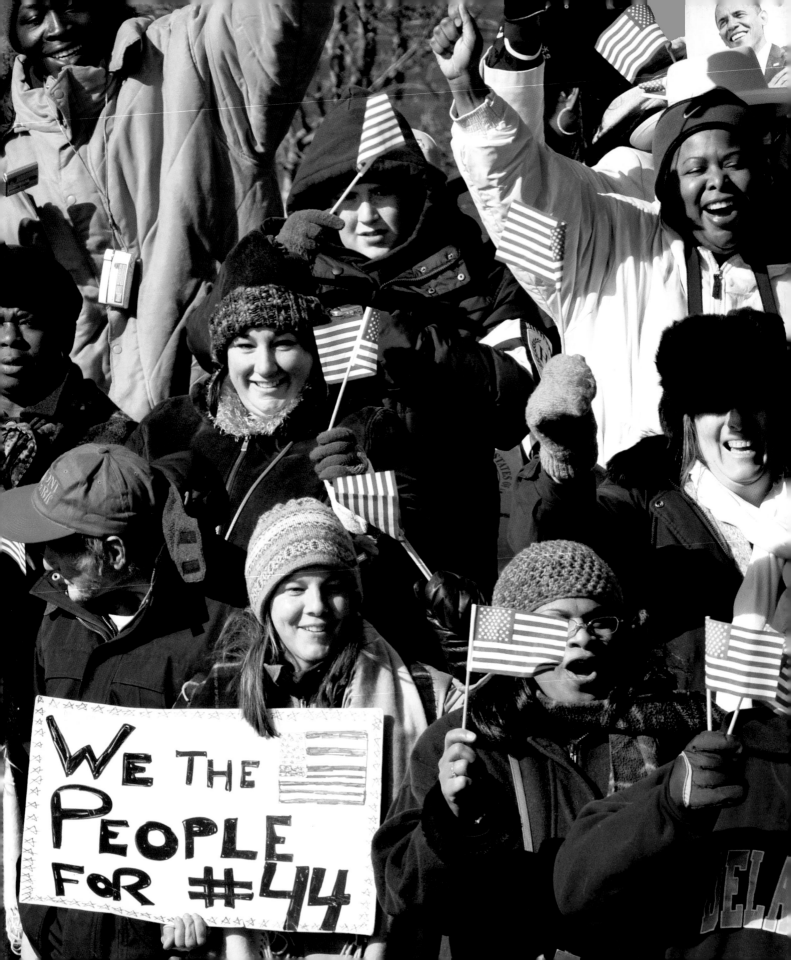

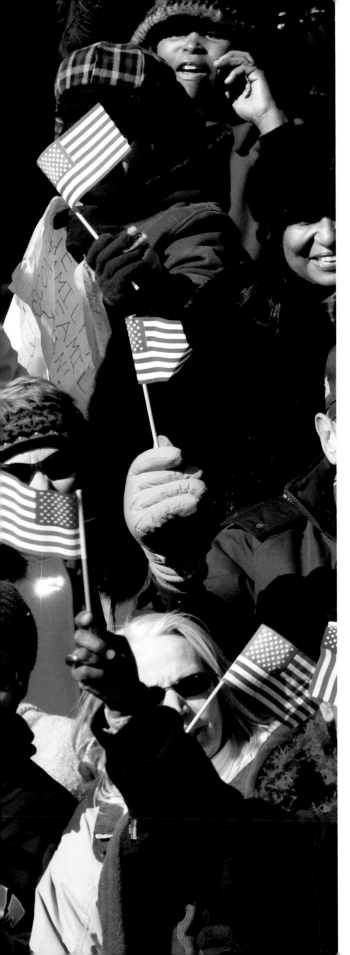

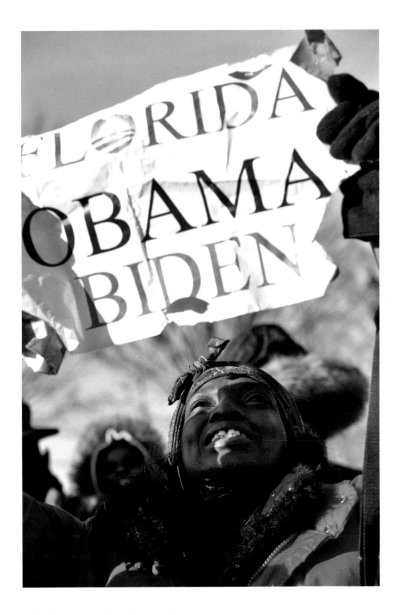

ABOVE: **Caroline Roya, from St. James City, Fla., joins in on her way to Washington.**

LEFT: **In Biden's hometown of Wilmington.**

Photos by Tracy Woodward

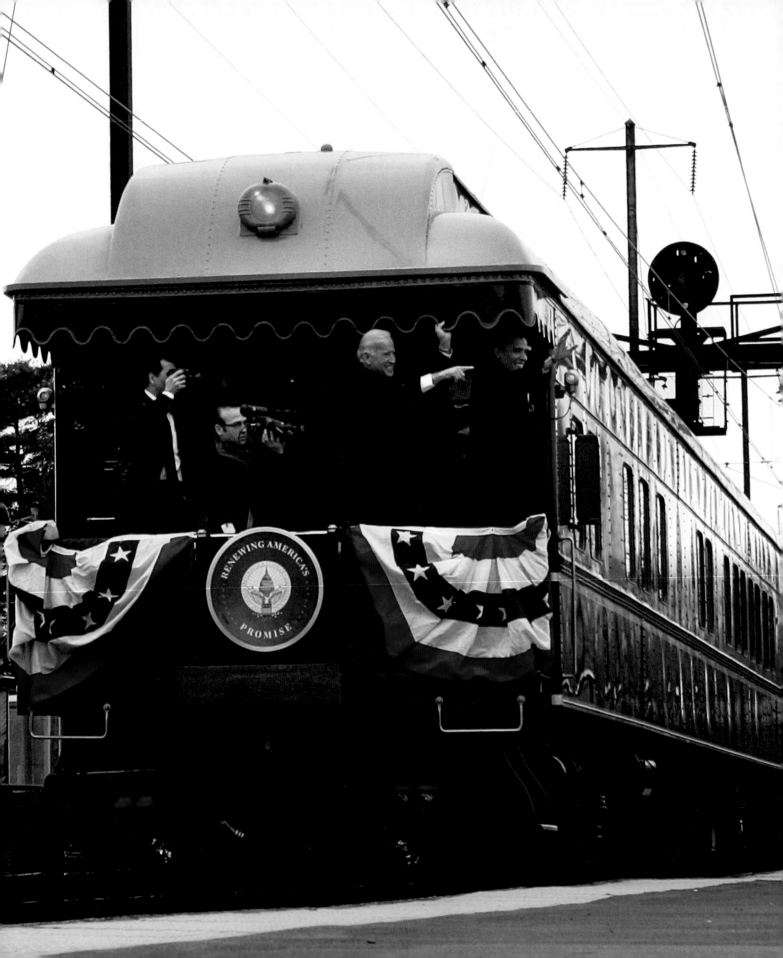

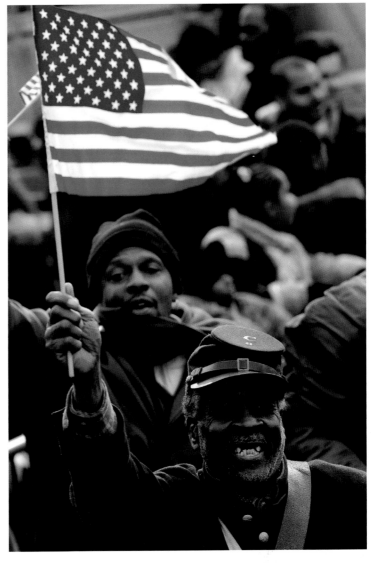

ABOVE: **Fans celebrate at the train station in Wilmington.**

LEFT: **Along the 137-mile route, Obama and Biden often stepped out of the car to engage with the throngs.**

Above photo by Linda Davidson; left by Preston Keres

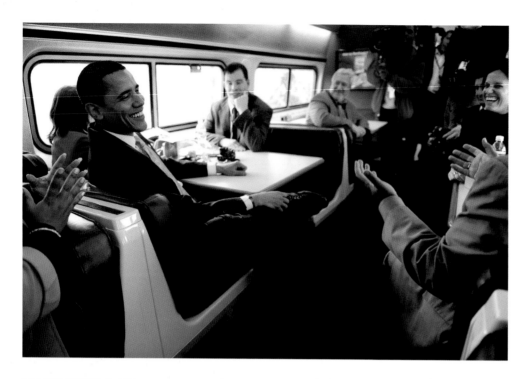

TOP: **Obama chats with friends, family and advisers aboard the train.**

ABOVE: **Obama has her back, at the Philadelphia rally.**

RIGHT: **Malia Obama and her dad head toward a platform in Philadelphia to speak with supporters.**

Top photo by Linda Davidson; above by Nikki Kahn; right by Melina Mara

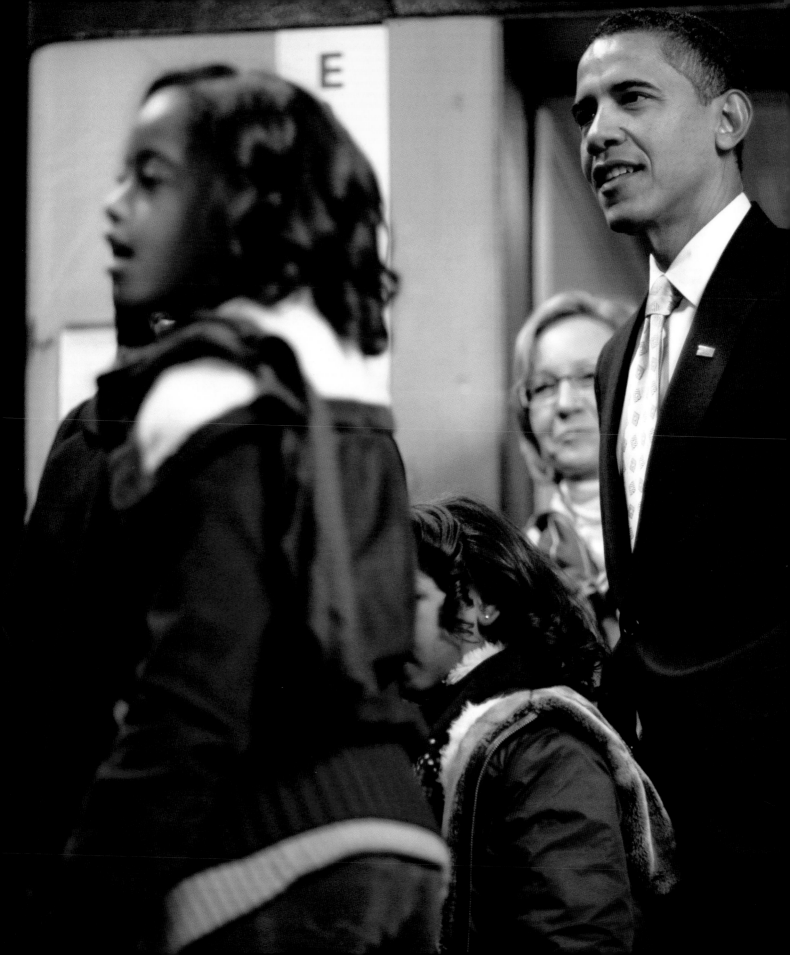

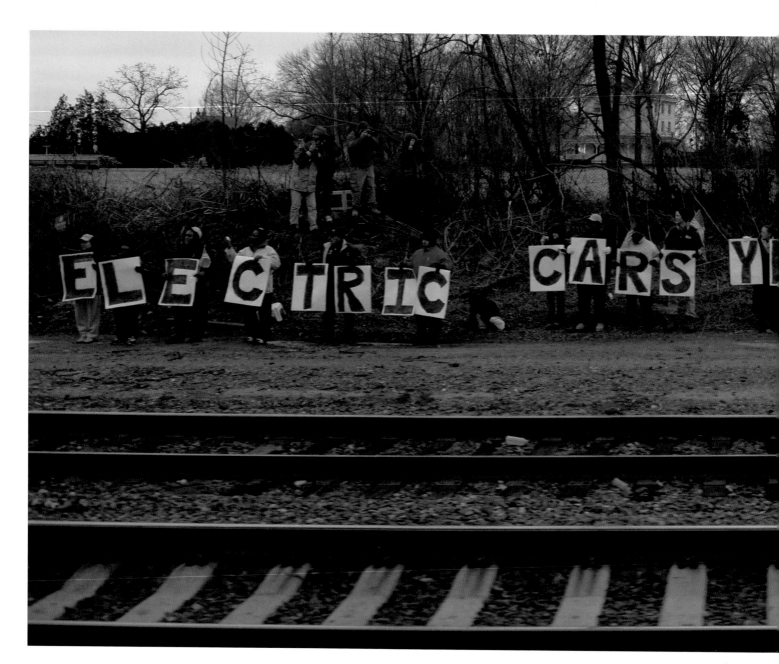

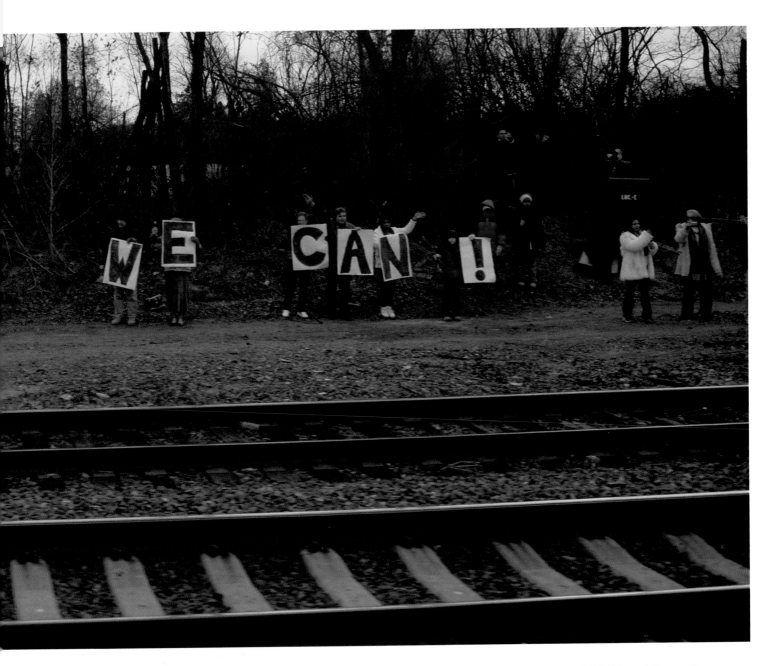

Views from the train.

Photos by Nikki Kahn

25

Residents of a Philadelphia neighborhood wave the train on.

Photo by Nikki Kahn

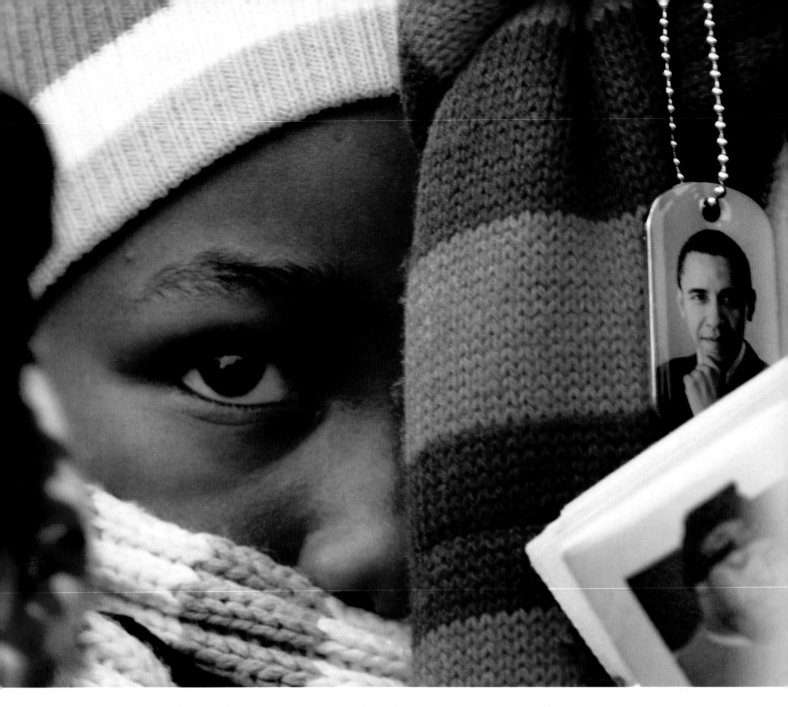

ABOVE: **Eight-year-old Ranoah Johnson at the rally in Baltimore.**

TOP RIGHT: **Joan Flynn in Baltimore.**

BOTTOM ROW: **Faces in the crowds in Wilmington and Baltimore.**

Above photo by Carol Guzy; opposite page top and bottom left by Linda Davidson; bottom center and right by Marvin Joseph

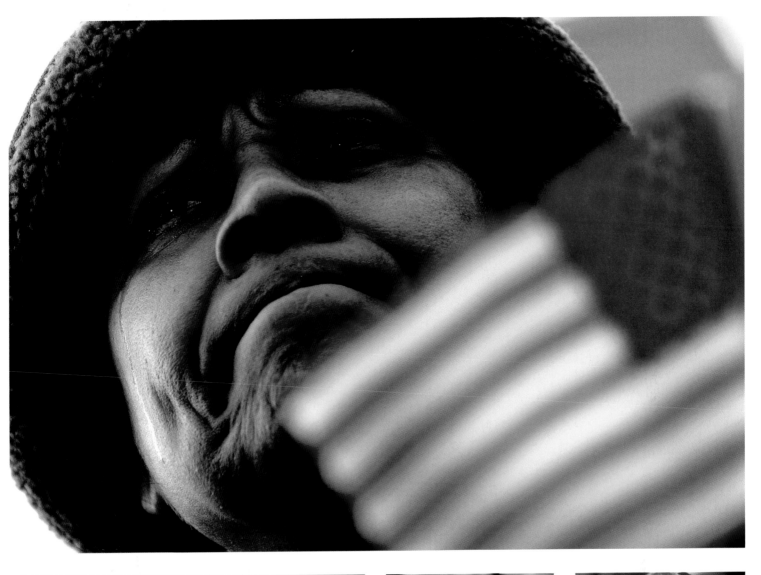

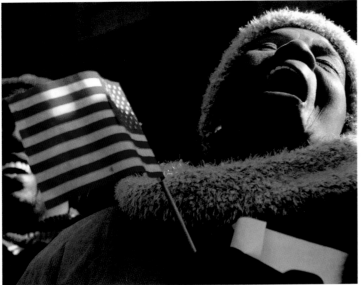

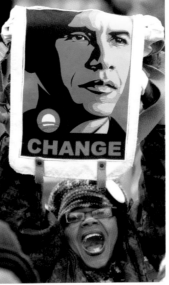

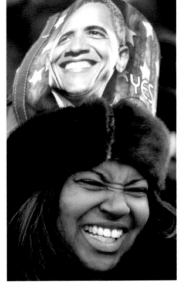

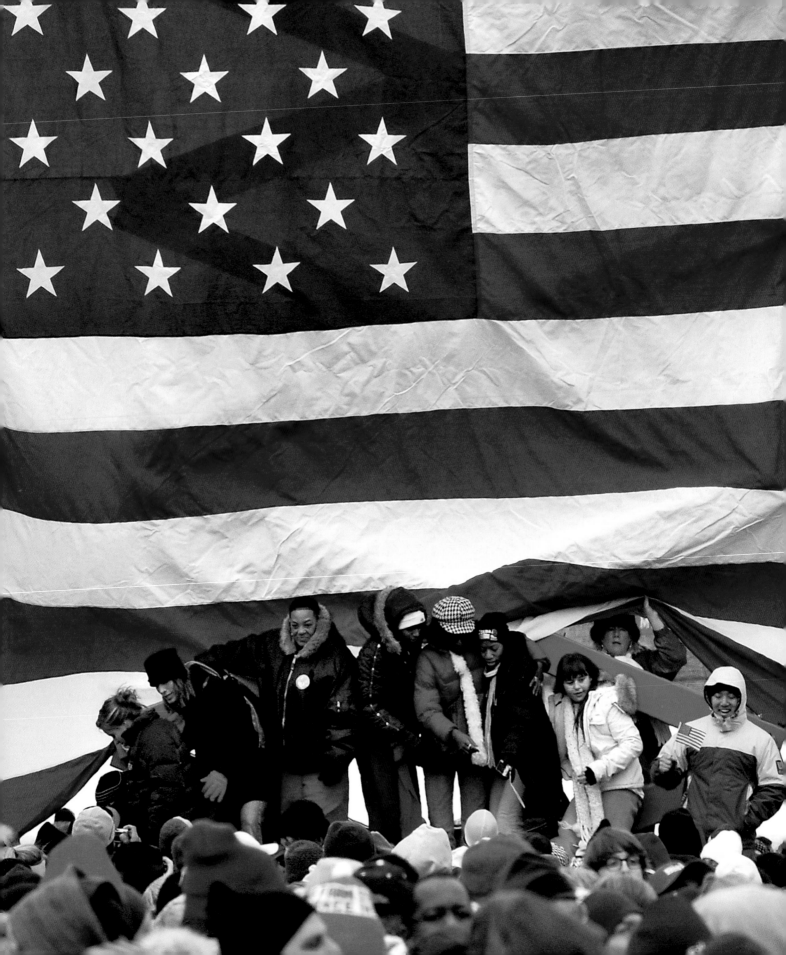

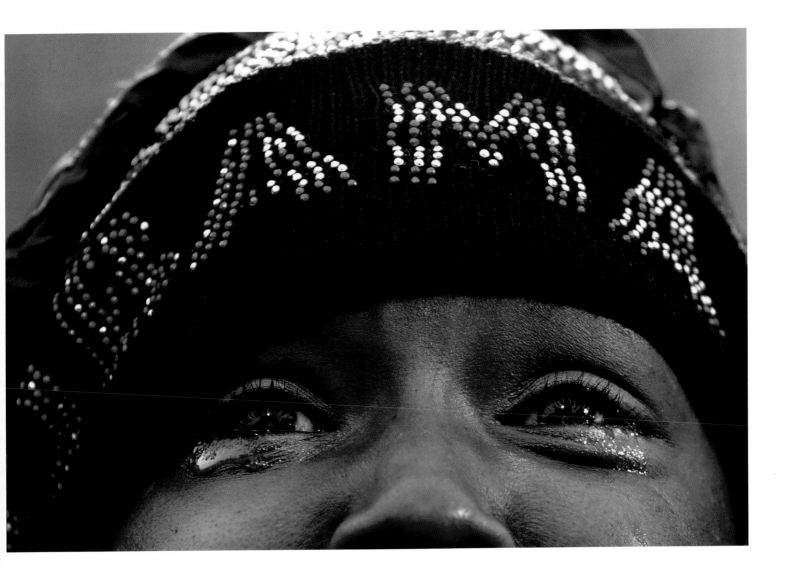

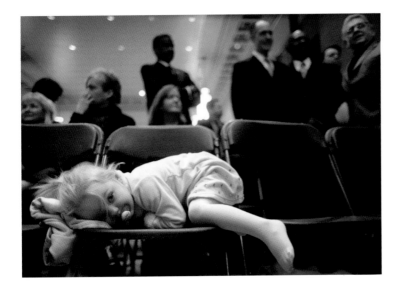

ABOVE: **Laterra Hopkins tears up as Obama takes the stage at the War Memorial Plaza in Baltimore.**

LEFT: **Two-year-old Maggie Murphy, daughter of Pennsylvania Congressman Patrick Murphy, rests as the adults await Obama's arrival at the 30th Street station in Philadelphia.**

OPPOSITE PAGE: **People in the back of the Wilmington train station scramble to get a better view.**

Above photo by Linda Davidson; left by Melina Mara; opposite by Tracy Woodward

EVER SINCE MAY 2007,
when Obama became the earliest
presidential candidate to be placed
under Secret Service protection,
he has bristled at the confines of
security. He complained when
advisers asked him to stop
running along Lake Michigan,
driving his own car or browsing
alone through his favorite Chicago
bookstore. He chafed at the
idea of giving up his BlackBerry
for security reasons during the
transition to the presidency.

**In a sea of Secret Service agents
at the Wilmington station, Obama
is the only one laughing.**

Photo by Nikki Kahn

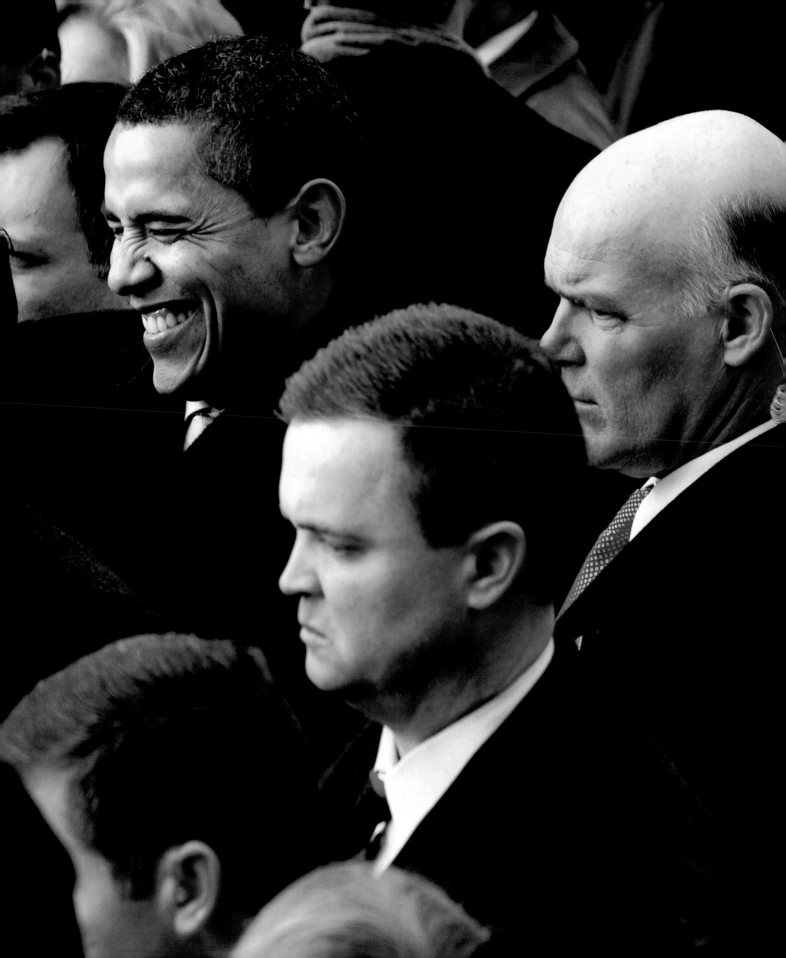

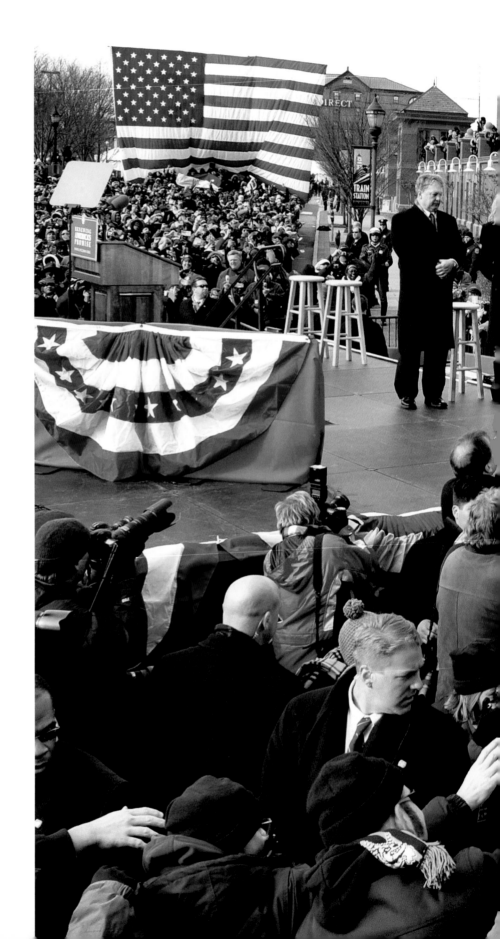

Obama joins the Bidens at a train-stop rally in Wilmington as Michelle Obama, center foreground, greets supporters on her way to the stage. The crowd of more than 7,000 later sang "Happy Birthday" to the incoming first lady, who turned 45.

Photo by Tracy Woodward

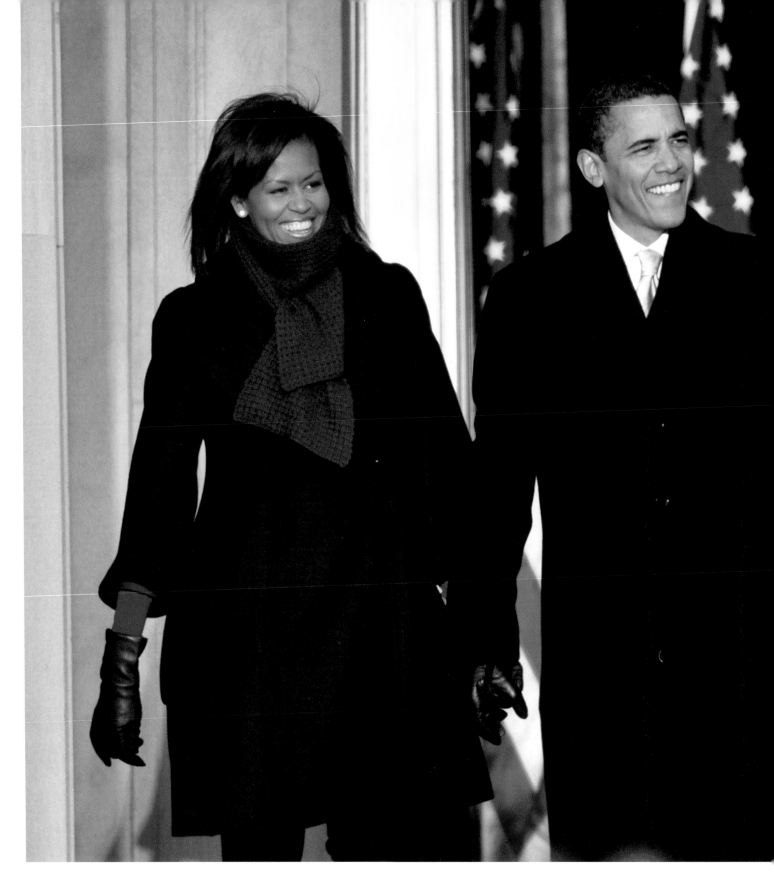

Onstage at the War Memorial Plaza in Baltimore, the Obamas and the Bidens.

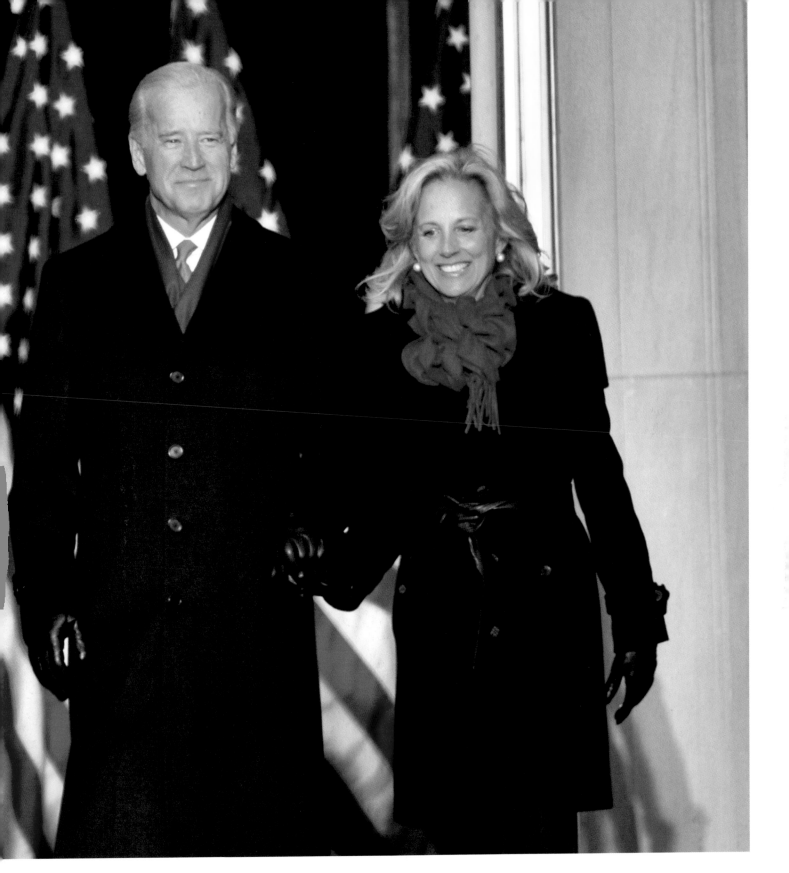

Photo by Marvin Joseph

66 We should never forget that we are the heirs of that first band of patriots.
We are the heirs of those who declared independence, ordinary men and women who refused
to give up when it all seemed so improbable and who somehow believed that they had the power
to make the world anew. That's the spirit that we must reclaim today."

**Cancer survivor Patricia Stiles, seated far left on the podium, gets a hug,
right, after introducing Obama in Philadelphia.**

Photos by Linda Davidson

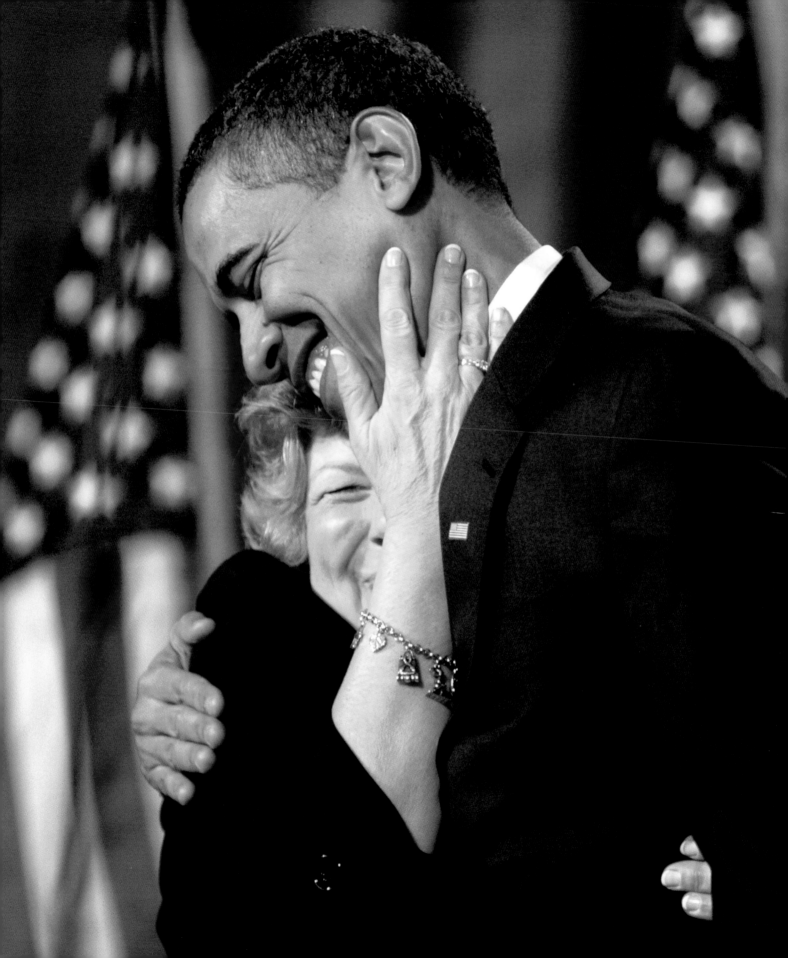

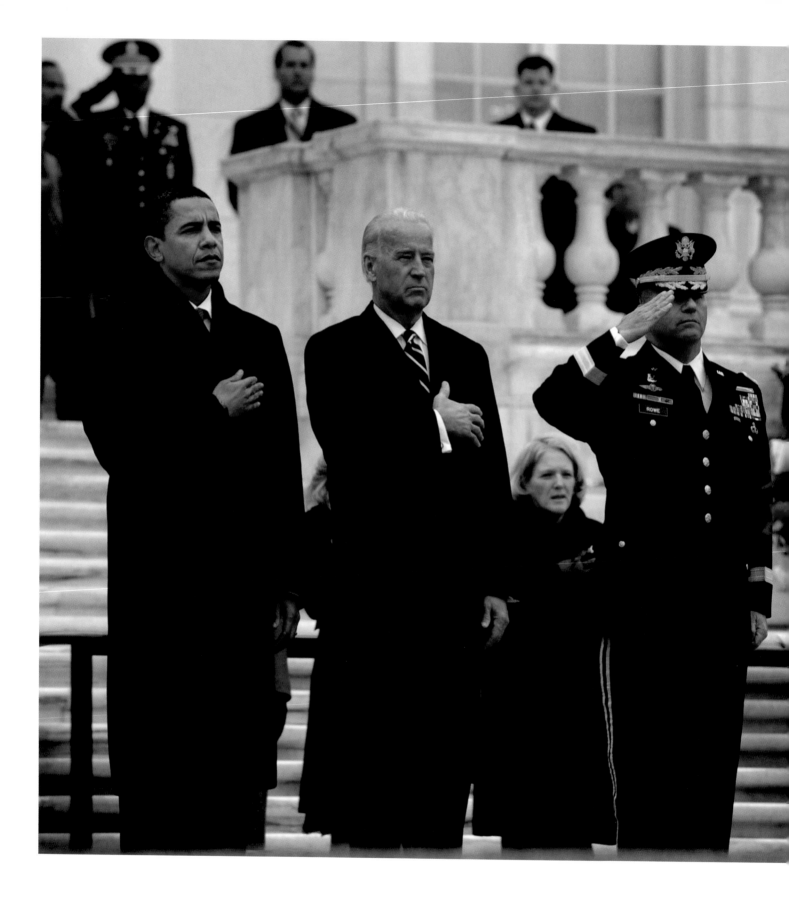

Honoring the Dead, Raising a Chorus

An anticipatory spirit began to consume the nation's capital on Sunday.

Obama started the day with a wreath-laying ceremony at the Tomb of the Unknowns and later he and his family attended a service at the Nineteenth Street Baptist Church. Hundreds of worshipers eagerly welcomed the Obamas for a service filled with spirit, song and Scripture at one of the oldest historically black churches in Washington.

Capping the day was an afternoon concert at the Lincoln Memorial, where rap fans danced to country music, elderly white men high-fived young African Americans and tears mixed with laughter as a varied lineup of A-list stars and an equally diverse crowd jammed the grounds.

By some estimates, more than 400,000 people filled the western end of the National Mall. They endured long security lines and chilly weather for a two-hour salute to the man who would soon be America's first black president.

Bruce Springsteen, Bono, Beyoncé and Garth Brooks took the stage, but no one remotely touched the star power of one guest: Every time the Jumbotrons flashed a shot of the president-elect, a thunderous roar erupted from the farthest reaches of the crowd.

Paying tribute at the Tomb of the Unknowns at Arlington National Cemetery.

Photo by Linda Davidson

41

Vice President-elect Joseph R. Biden Jr. holds his two-year-old grandson, Robert Hunter Biden, after Mass at Holy Trinity Catholic Church in Georgetown.

Photo by Melina Mara

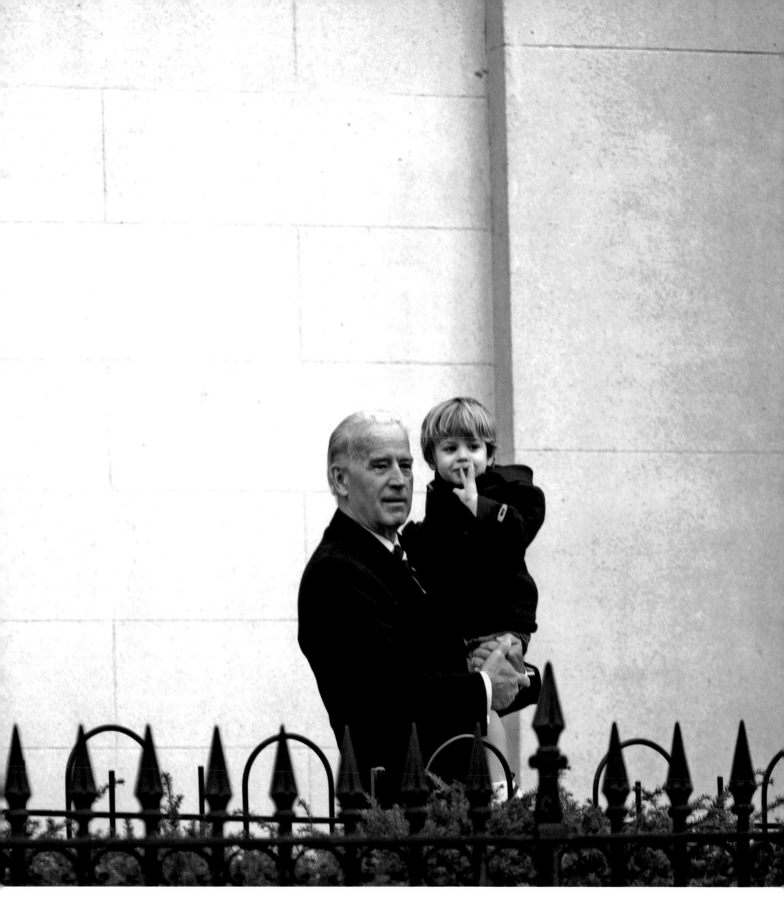

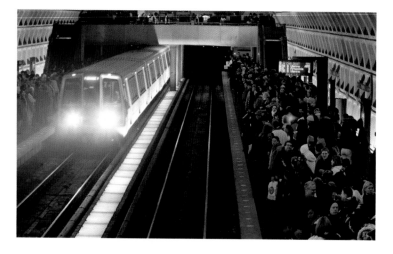

ABOVE and RIGHT: **The scene at the Farragut West station. For the star-studded inaugural concert, Washington's Metro system handles 616,324 trips, a record for a Sunday.**

BELOW: **The 44th president-elect merits a special license plate on a new armored Cadillac.**

Above and right photos by Melina Mara; below by Linda Davidson

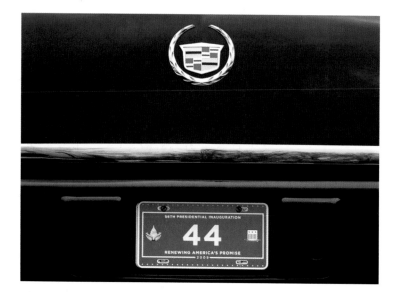

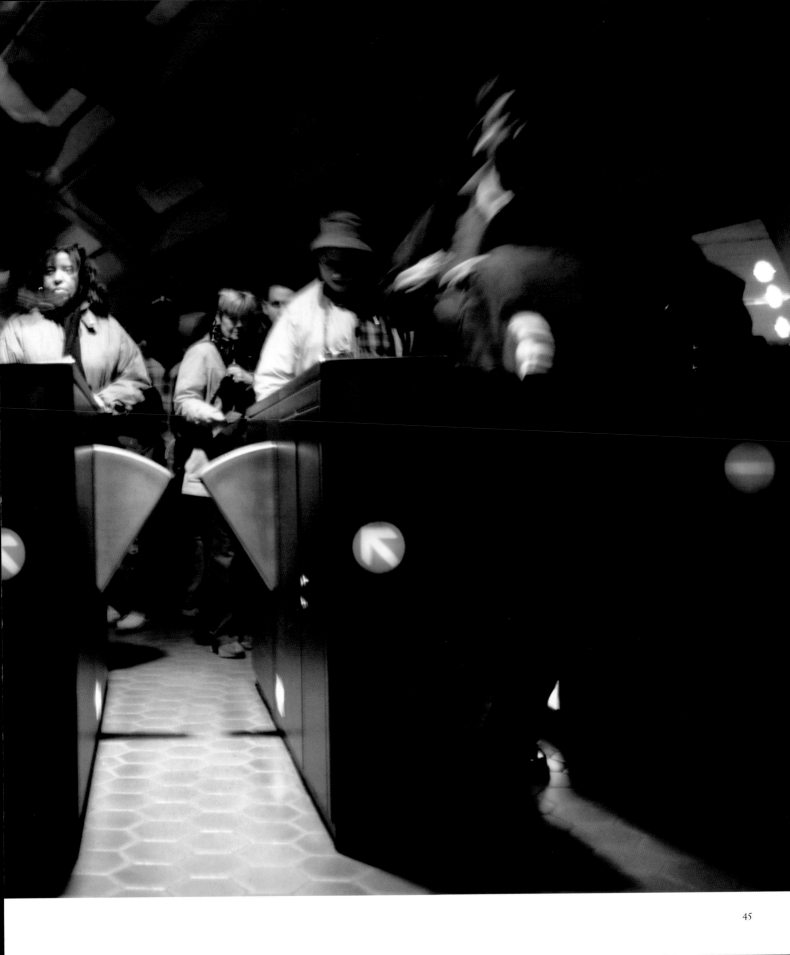

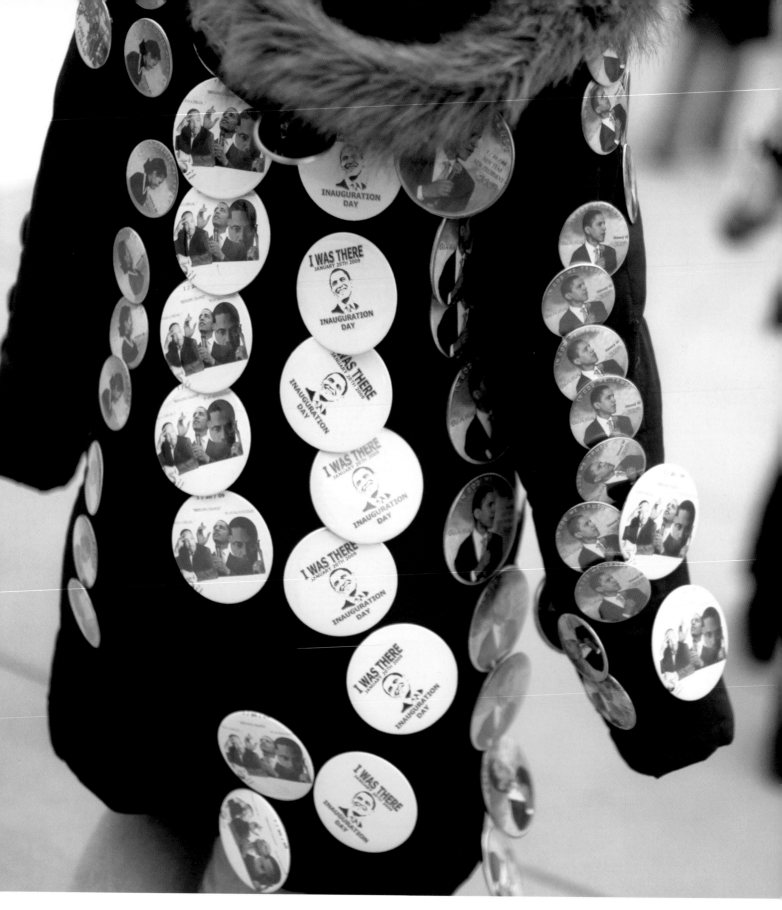

46

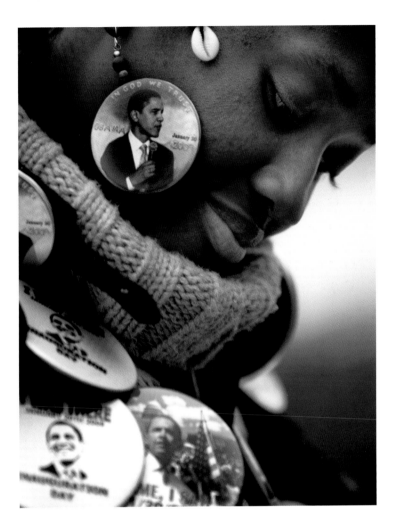

ABOVE and LEFT: **Raet Ankhhetep sells homemade buttons during the mega-concert.**

Photos by Melina Mara

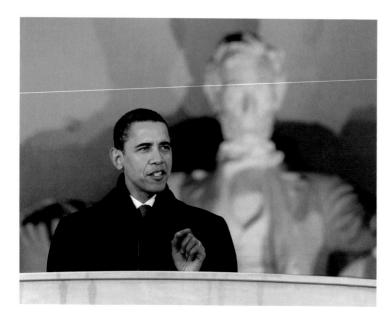

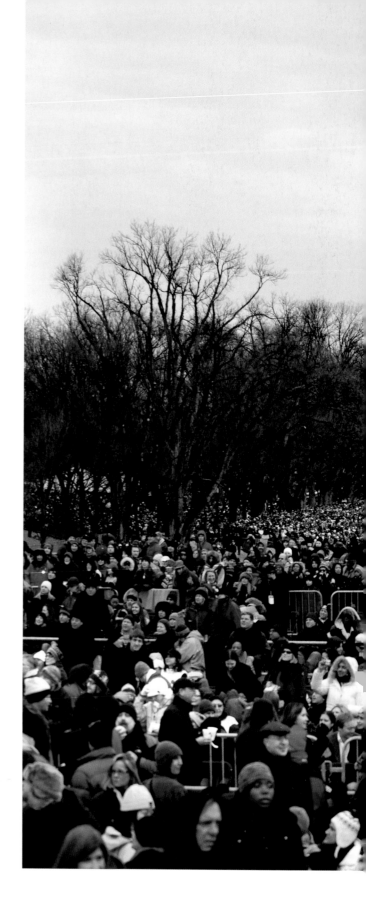

 ❝ What gives me the greatest
hope of all is not the stone and
marble that surrounds us today,
but what fills the spaces in between.
It is you — Americans of every race
and region and station —
who came here because you
believe in what this country
can be and because you want
to help us get there.”

**Hundreds of thousands pack the
Mall for the "We Are One" concert.**

Photos by Linda Davidson

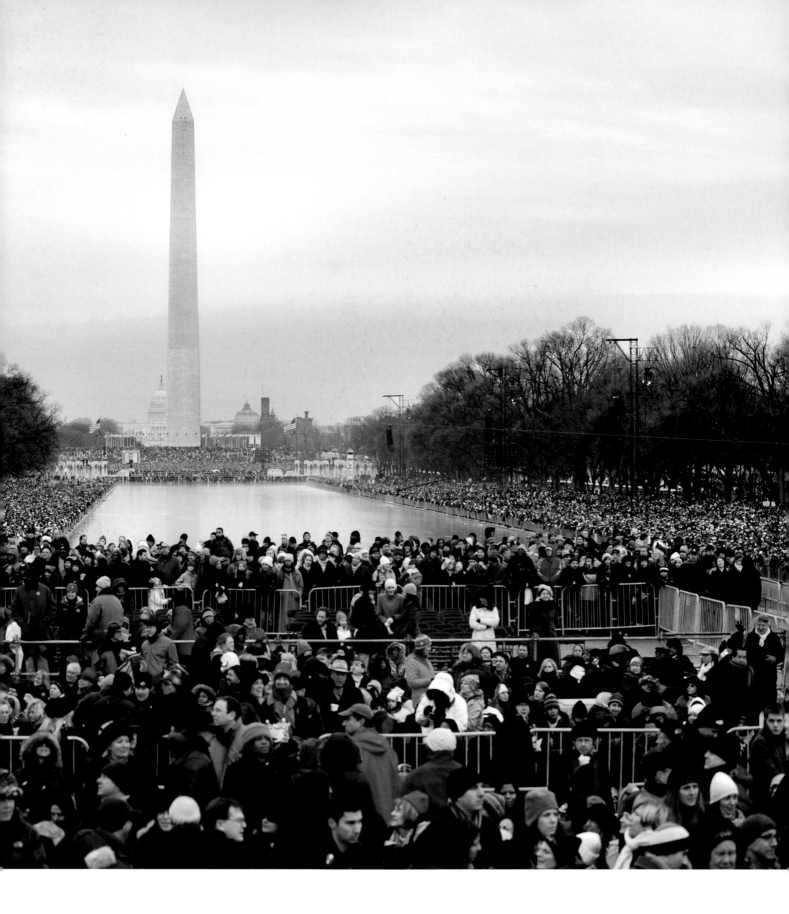

THE CONCERT AT THE
Lincoln Memorial produces many
stirring moments, extending
the Mall's long history as a venue
that mixes politics and music.
Some people start crying when
Obama speaks. Others well up
at U2's performance of "Pride,"
connecting to the significance
of hearing it at the site
of Martin Luther King Jr.'s
"I Have a Dream" speech
46 years ago.

Photo by Lucian Perkins

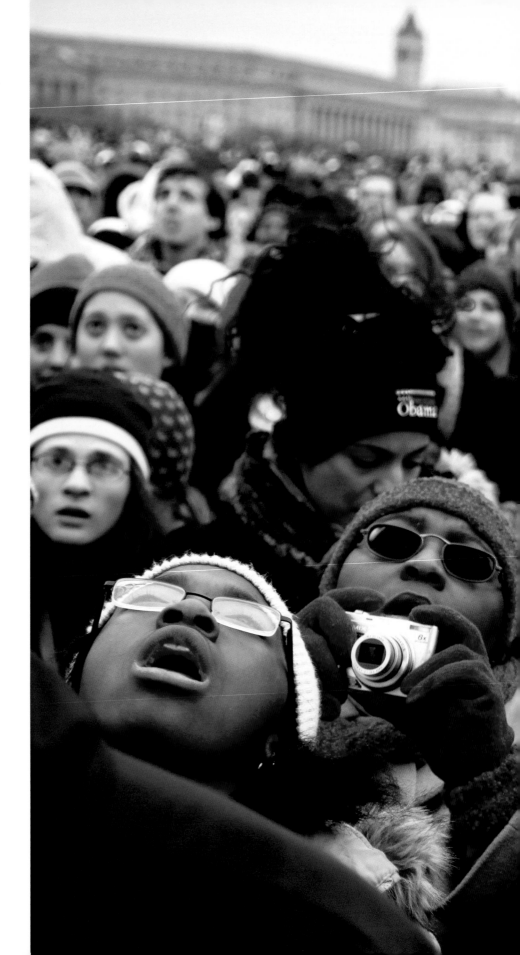

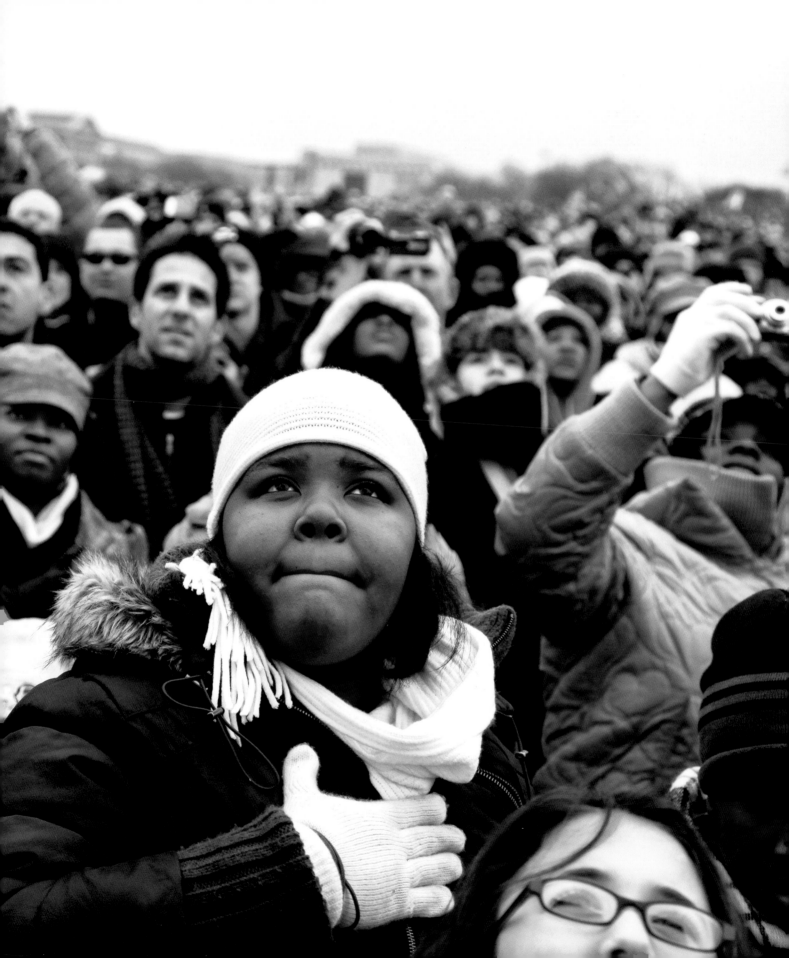

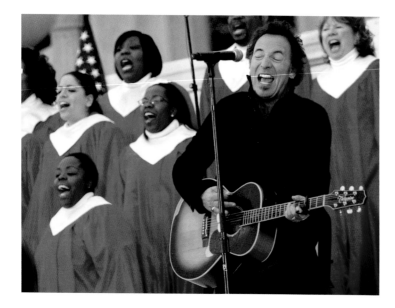

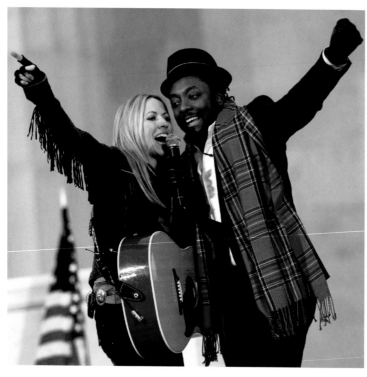

TOP and ABOVE: **Bruce Springsteen gets things started with his own song, "The Rising," and Sheryl Crow joins will.i.am in Bob Marley's "One Love."**

RIGHT: **Country music star Garth Brooks, backed by the Washington Youth Choir, brings the crowd to its feet with a medley of "American Pie," "Shout" and "We Shall Be Free."**

Photos by Linda Davidson

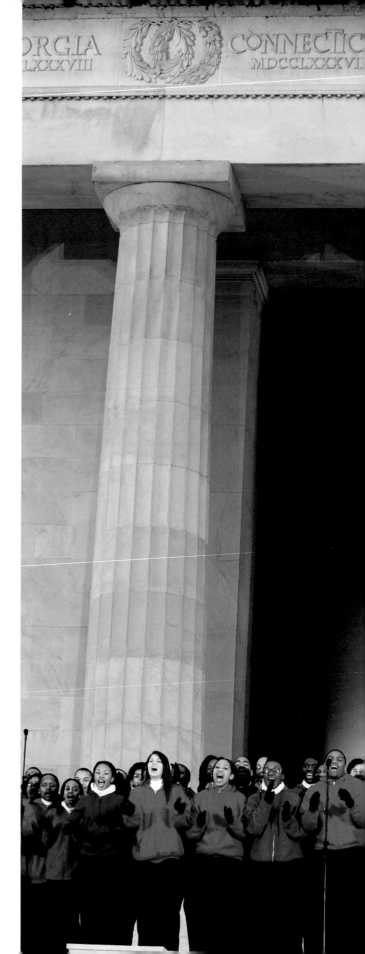

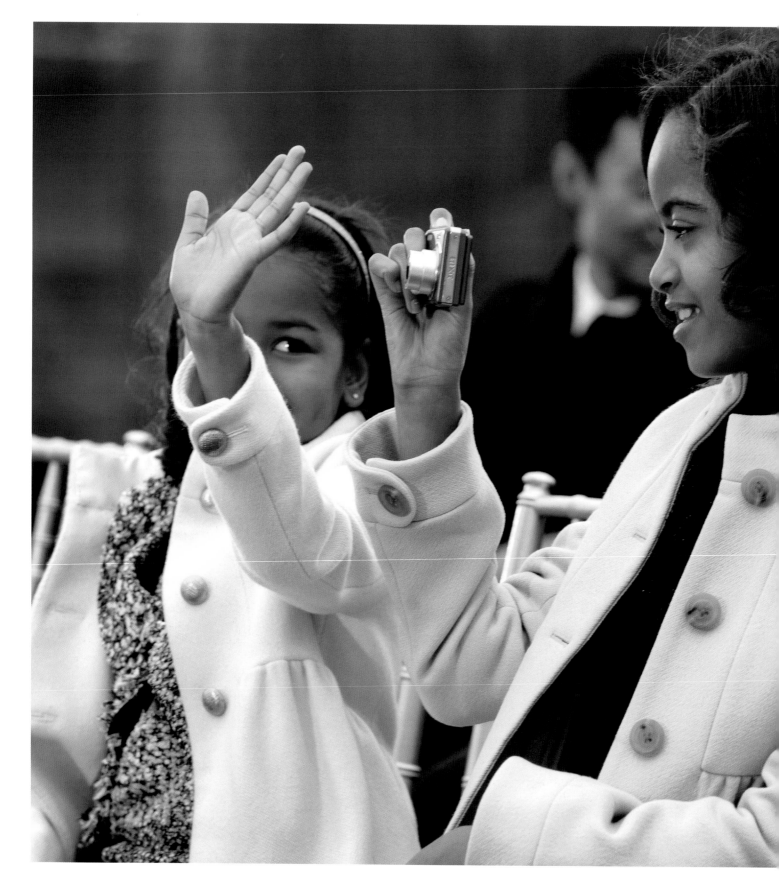

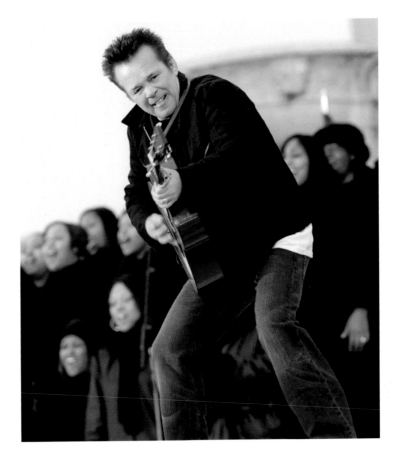

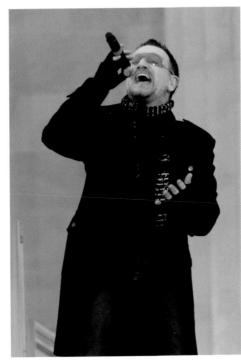

ABOVE: **John Mellencamp rocks the crowd with his signature "Pink Houses."**

LEFT: **Bono belts out U2's "City of Blinding Lights," which Obama had used at campaign events.**

OPPOSITE PAGE: **Sasha Obama playfully interferes with her sister as Malia tries to take pictures of the celebration.**

Photos by Linda Davidson

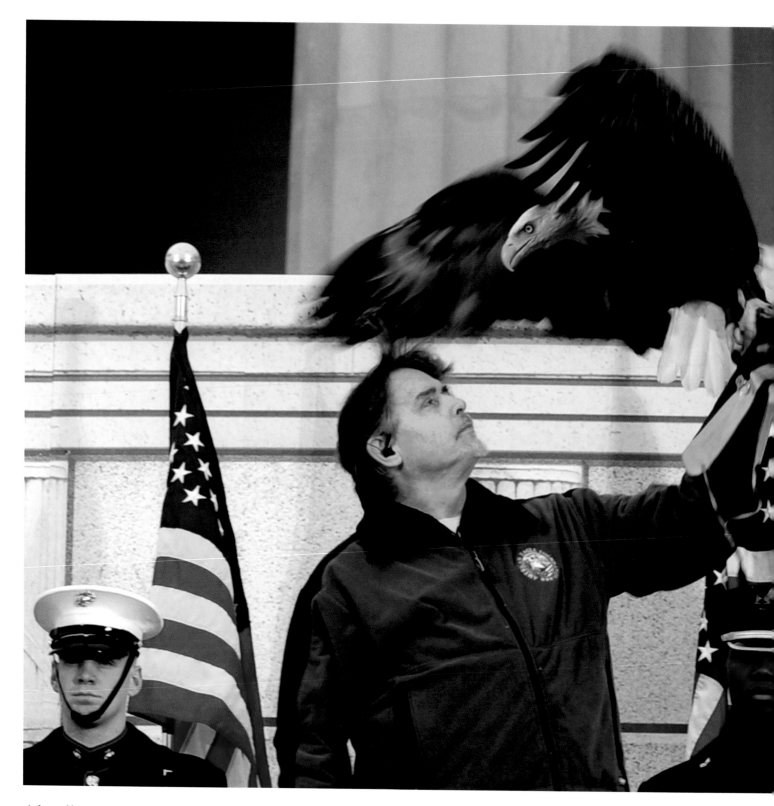

A handler presents a bald eagle, the national bird, as a military color guard looks on.

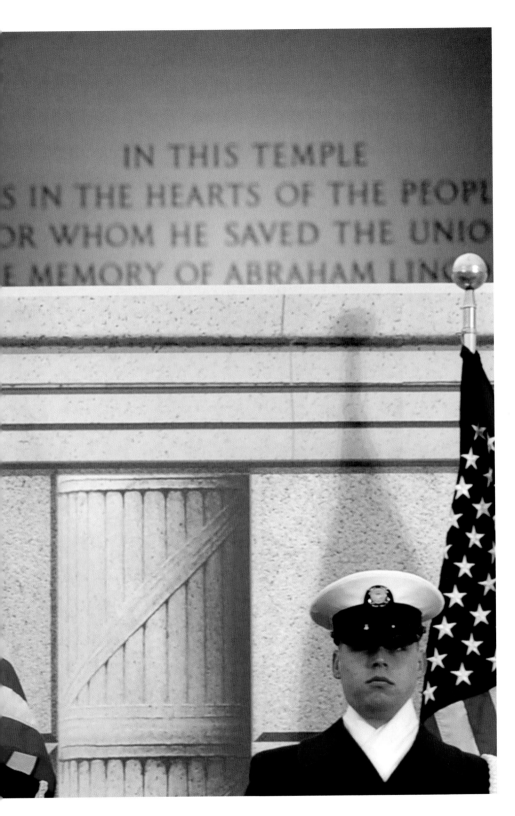

Photo by Linda Davidson

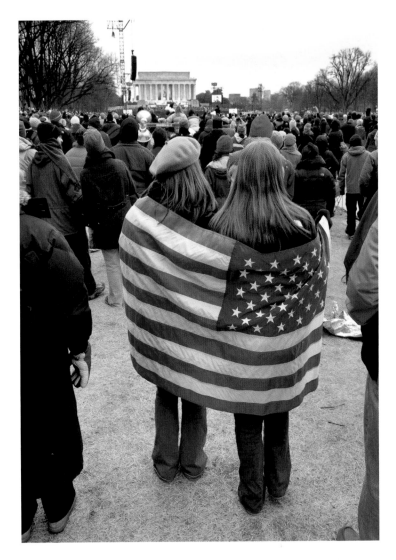

ABOVE and LEFT: **At the concert.**

Above photo by Bill O'Leary; left by Lucian Perkins

59

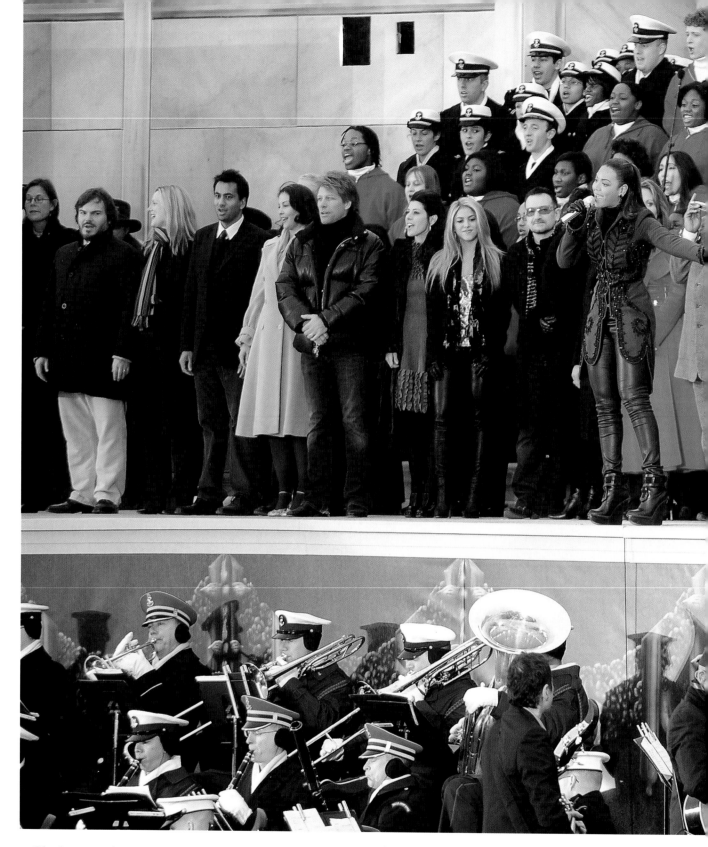

Closing out the nearly two-hour spectacle, pop star Beyoncé, accompanied by Stevie Wonder on harmonica, leads the celebrity cast in "America the Beautiful": from left, Jack Black, Laura Linney, Kal Penn, Ashley Judd, Jon Bon Jovi, Marisa Tomei, Shakira, Bono (obscured, Bettye LaVette, the Rev. Gene Robinson, Renée Fleming), Beyoncé, Stevie Wonder and personal assistant Ron Taylor, Tao Rodriguez-Seeger, Pete Seeger,

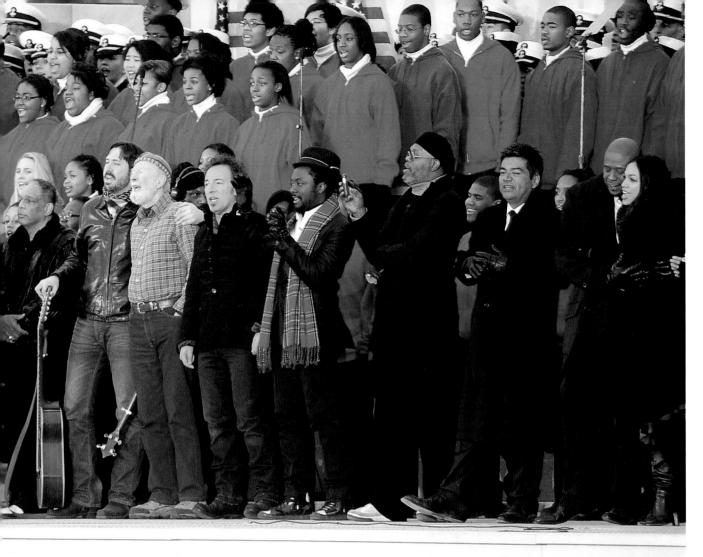

Bruce Springsteen, will.i.am, Samuel L. Jackson, George Lopez, Forest Whitaker, Rosario Dawson.
Other acts include the U.S. Naval Academy Glee Club, Inaugural Celebration Singers, Washington Youth
Choir and Joint Service Orchestra.

Photo by Gerald Martineau

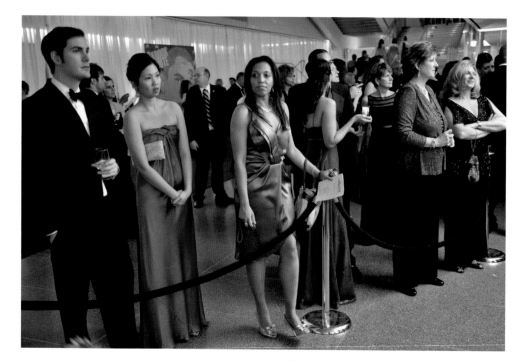

CLOCKWISE FROM TOP: **Sisters Nadia Pinto, left, and Carin Pinto pose with a cutout of the president-elect at the Root Inaugural Ball at the National Museum of American History; model Cherie Burns-Scurry sweeps in with fashion designer and stylist Glynn Jackson; attendees watch for celebrities.**

Photos by Marvin Joseph

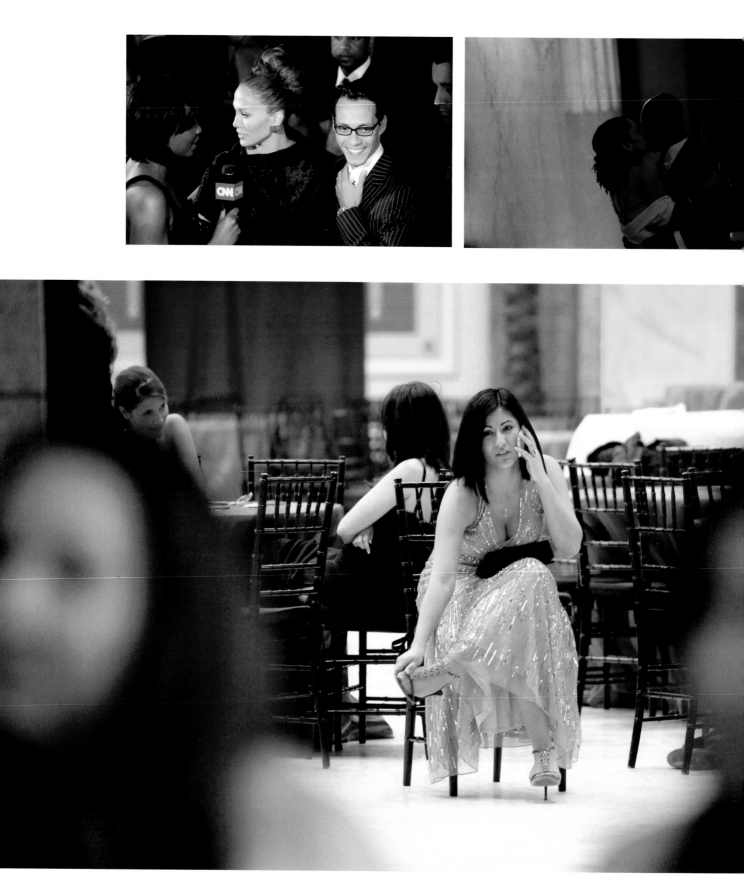

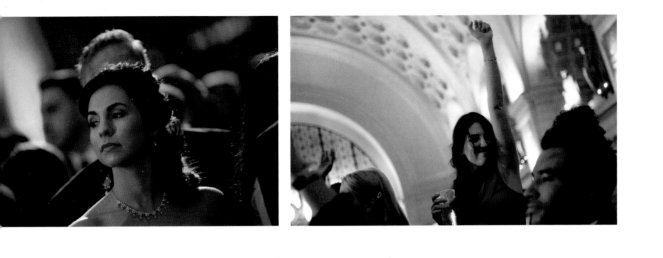

CLOCKWISE FROM LEFT: **Ana Devillegas of Gainesville, Va., rubs her feet as the Latino Inaugural Gala at Union Station draws to a close; pop star Jennifer Lopez and her husband, singer Marc Anthony, pause for a television interview as they enter the gala; Kamala Greene and Edwin Genece, both of New York, get personal in the VIP room; Sarah Sanchez of Washington, D.C.; Merquit Garcia of Washington, D.C.; high heels prove blue and red can go together.**

Photos by Sarah L. Voisin

Answering
A Call to Service

Hundreds of thousands of volunteers turned out to do good works for their communities, an overwhelming response to Obama's call for a day of public service on the Rev. Martin Luther King Jr.'s birthday.

They crowded into soup kitchens to feed the homeless, flooded school hallways to paint walls and flocked to neighborhood parks to pick up trash in what may have been the largest day of national service ever. It was propelled by the same kind of millions-strong network of e-mail and text messages that marked Obama's presidential campaign.

The impact was particularly strong in Washington, bolstered by the thousands who arrived in recent days for the inauguration and who eagerly joined the area's community service activities.

Friends who spent time with the president-elect said he seemed at ease on the eve of his inauguration. He shuttled among several events, including a dinner honoring Sen. John McCain of Arizona, where he embraced his Republican opponent in the November election, hailing him as "an American hero."

Helping to paint a wall "laguna blue" at the Sasha Bruce Youthwork shelter for homeless teenagers near Capitol Hill.

Photo by Linda Davidson

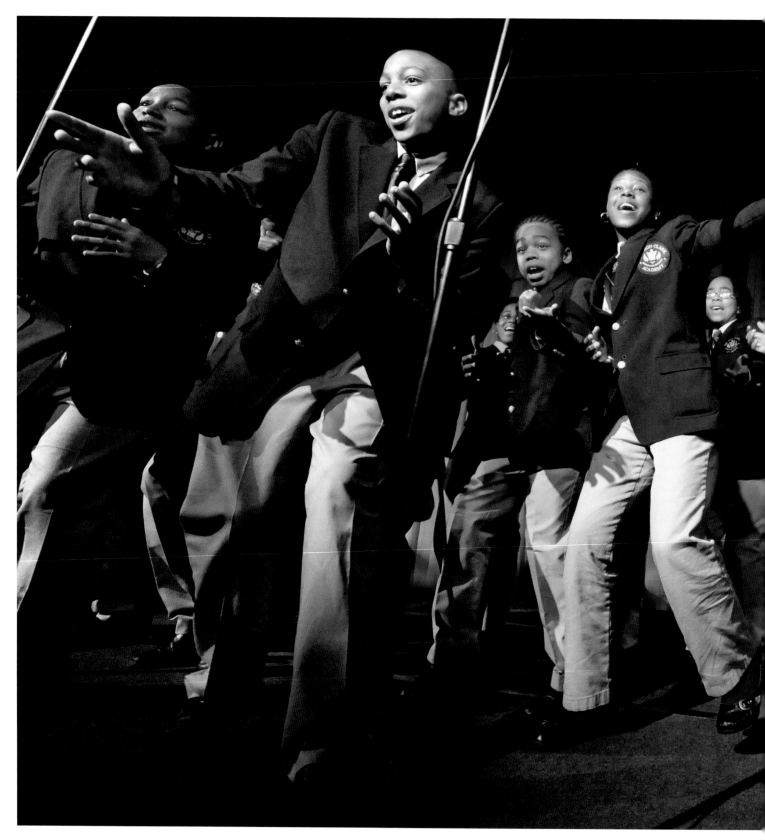

Students from the Ron Clark Academy in Atlanta do a musical tribute to Obama and Martin Luther King Jr. at the project's prayer breakfast at the JW Marriott Hotel.

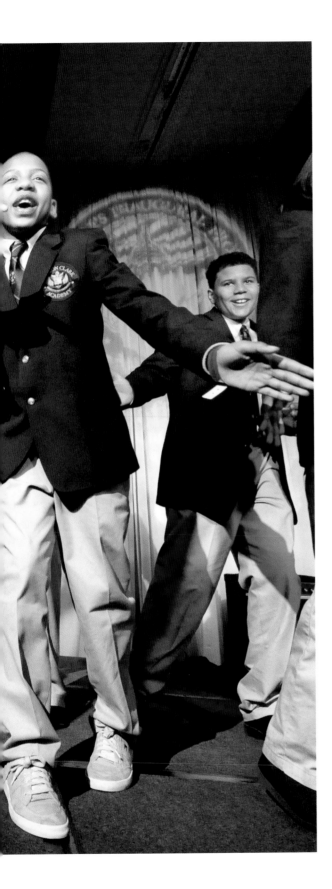

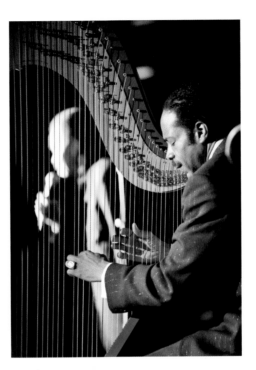

The People's Inaugural Project by the Stafford Foundation brings 1,000 disadvantaged people to the inauguration.

TOP: **Jeff Majors performs.**

Photos by Tracy Woodward

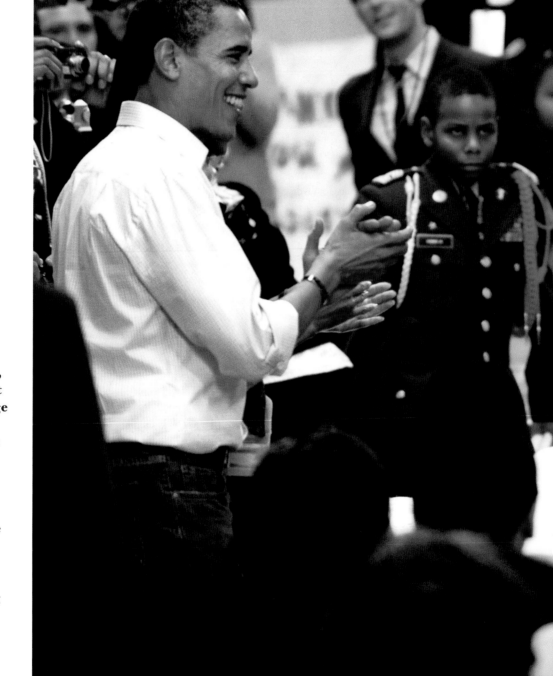

As part of the Day of Service, cheerleaders at Calvin Coolidge High School in Washington have a special cheer for Obama. Coolidge students wrote letters and made blankets for soldiers, as well as sending them video messages.

Photo by Linda Davidson

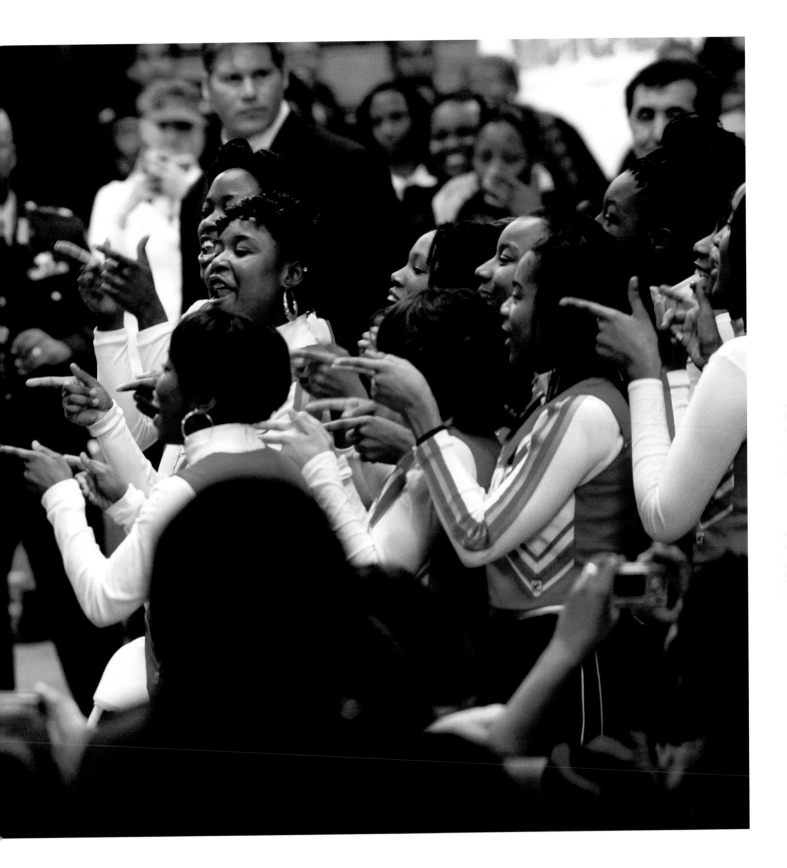

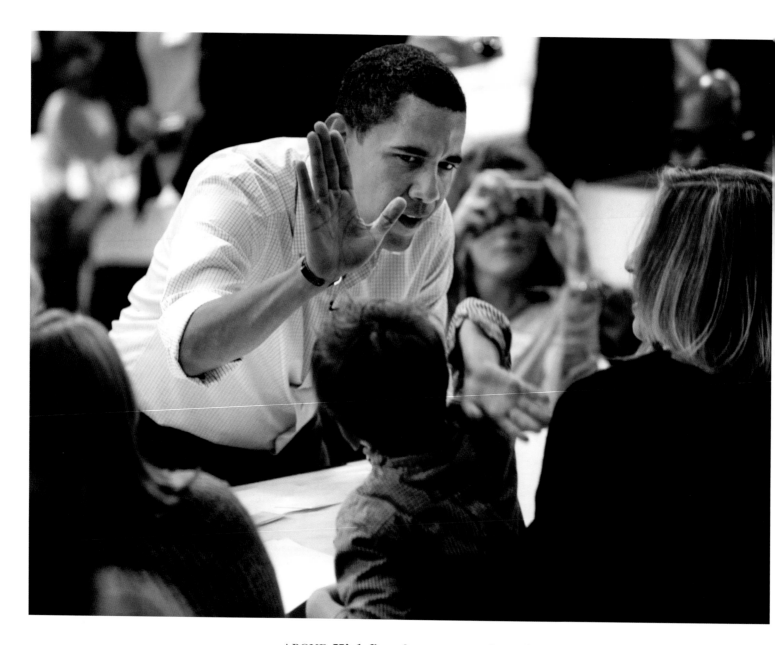

ABOVE: **High fives for one young boy who participated in the Day of Service by volunteering at Calvin Coolidge High School with his mother.**

RIGHT: **Jedi Scott has a moment the 10-month-old's parents will make sure is remembered.**

Photos by Linda Davidson

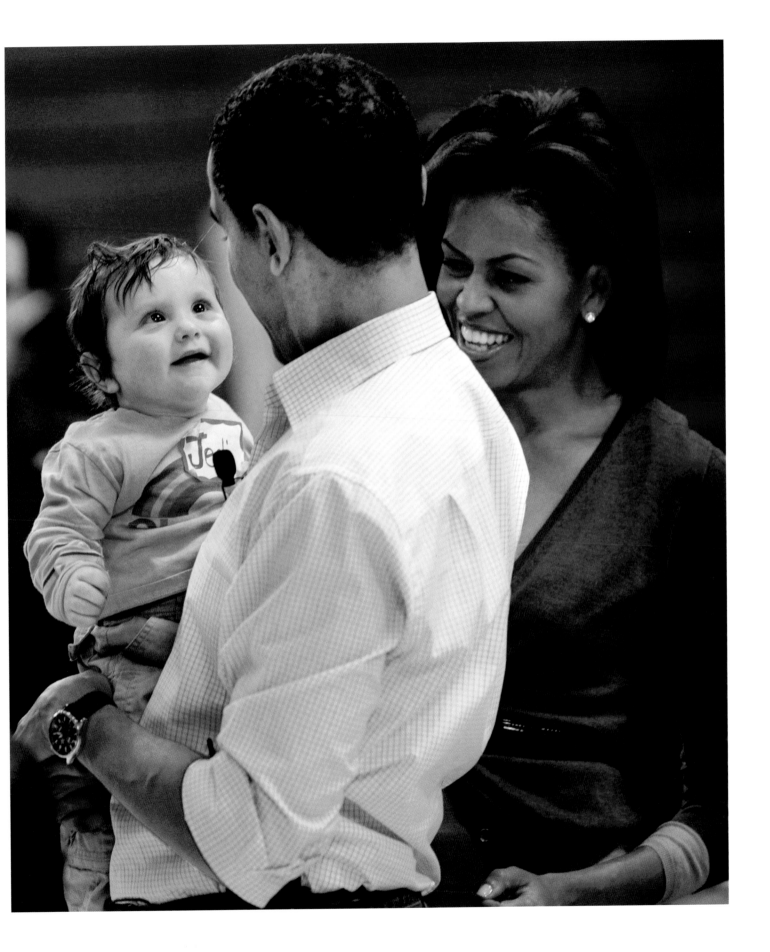

OBAMA WAS STILL WEARING a metal bracelet with silver lettering given to him in February 2008 by Tracy Jopek of Merrill, Wis. It's marked with the name of Sgt. Ryan David Jopek, who at age 20 was killed in Iraq by a roadside bomb on Aug. 2, 2006. "All gave some — He gave all," it reads.

Obama's arm encircles his wife at the Day of Service at Calvin Coolidge High School.

Photo by Linda Davidson

75

WOULD SHE BE ANOTHER HILLARY CLINTON?
Would there be a touch of Jackie Kennedy?
Eleanor Roosevelt? Nobody was announcing,
as the Clintons did, that we would get two for one
with the Obamas. But what would we get?
Michelle Obama, the Harvard-trained lawyer who
grew up on the South Side of Chicago, has said
that she will focus on work-family balance issues,
community service and military families.
"In the months to come," a transition official said,
"Mrs. Obama will define the role of first lady
for herself — blending family and issues of great
importance to her." Up close, crowds pressed to
get closer to her. And she seemed to like them back.

**At RFK Stadium, chatting with volunteers as they
assemble 75,000 care packages for military men
and women overseas.**

Photo by Lois Raimondo

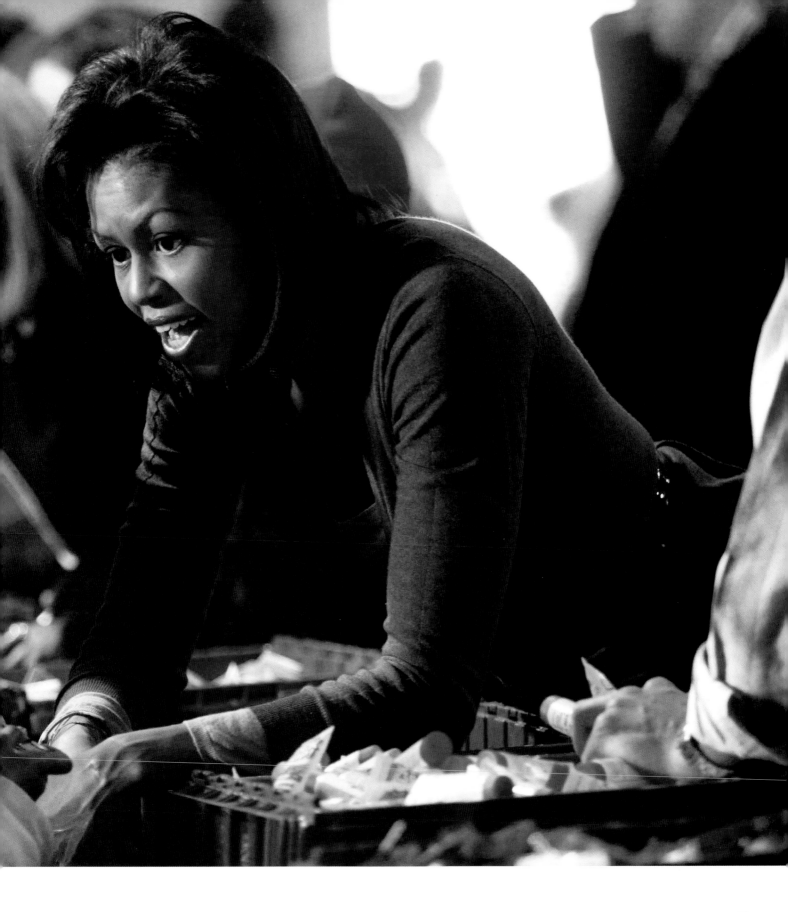

Even with naps and iPods, it's a long road to Washington for Olivia Cunningham, left, and Martina Going.

Photos by Mark Gail

THEY CAME FROM SELMA, ALA., THE CITY whose name was seared into the American psyche on March 7, 1965. State troopers attacked more than 600 protesters who were marching peacefully across the Edmund Pettus Bridge on their way to the state capital, in their campaign for voting rights. Without the struggle for voting rights centered in Selma, there might not be a President Obama. To celebrate his inauguration, the city sent at least three buses, including a contingent from Selma High. Their journey began with this simple prayer: "Jesus, we thank you for having the 44th president of the United States as a black African American."

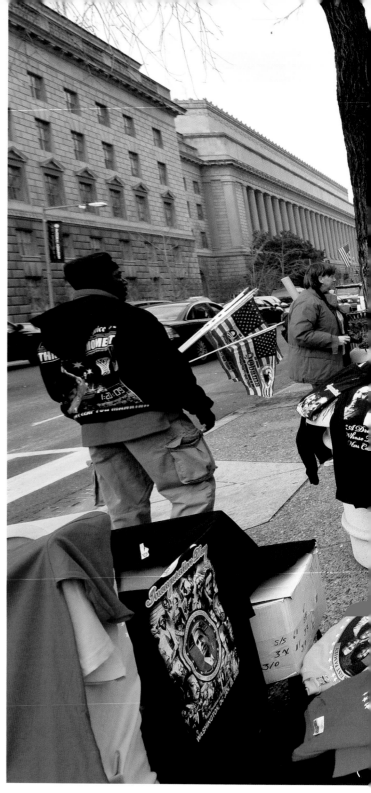

Selma students Le'Asia Crum, Eric Roussell and Mark Black, front, don't need any more Obama T-shirts on their way to the National Mall.

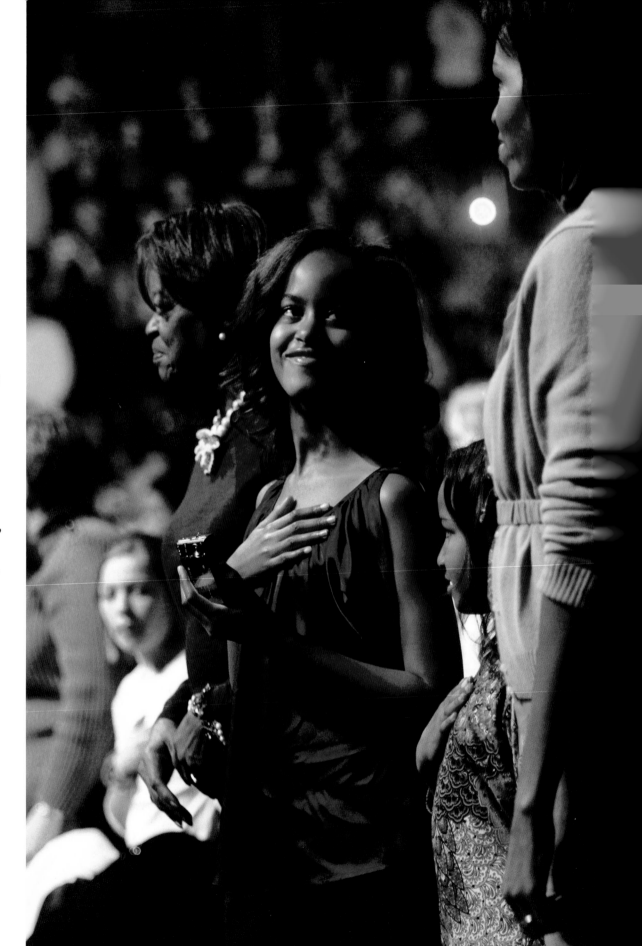

Malia, standing next to her sister, Sasha, beams at her mother from her front-row seat at "The Kids' Inaugural: We Are the Future" concert at the Verizon Center.

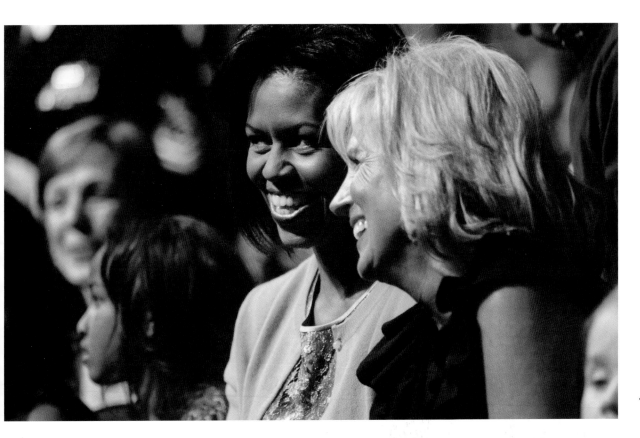

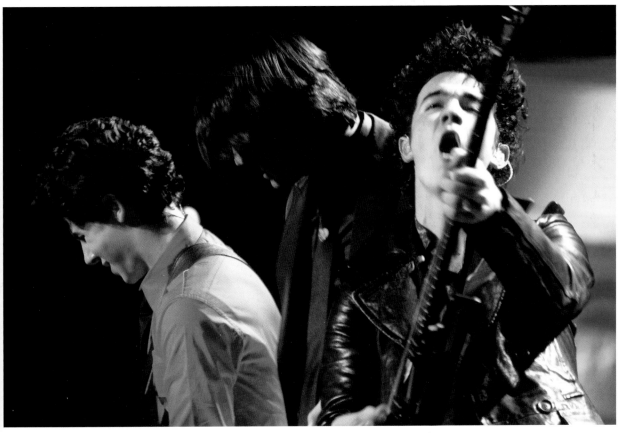

TOP: **Michelle Obama and Jill Biden, official hosts of this first-ever inaugural event for the YouTube generation.**

BOTTOM: **The Jonas Brothers' closing three-song set brings the crowd to its feet.**

Photos by Lois Raimondo

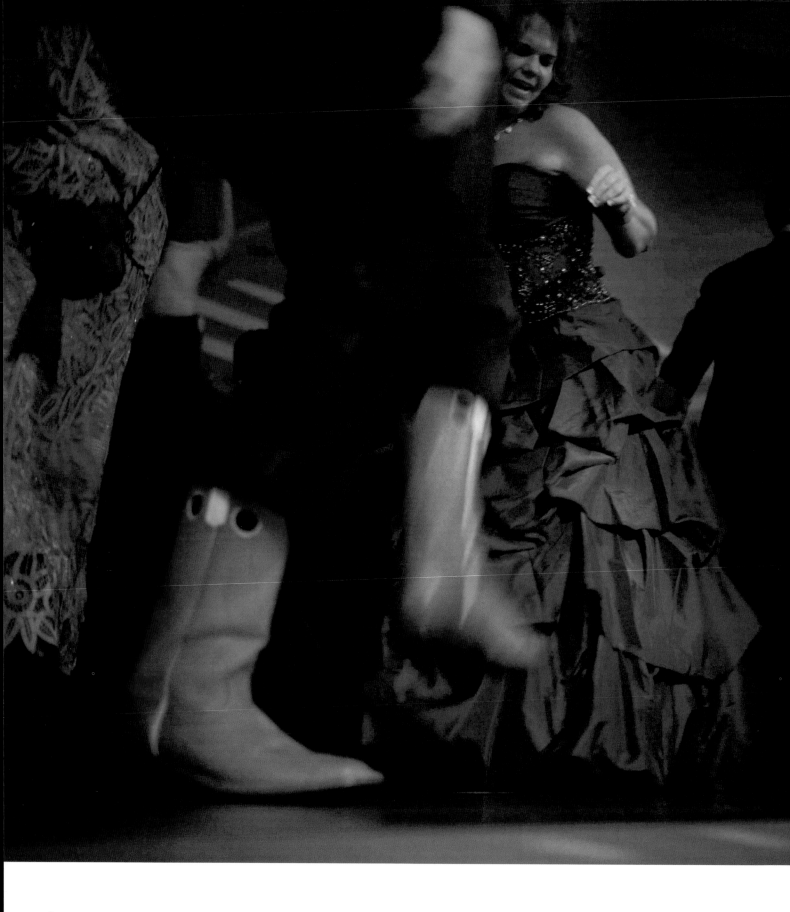

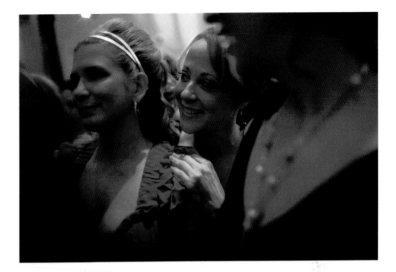

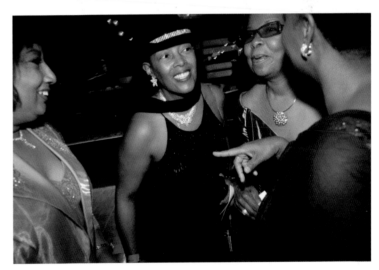

The Black Tie & Boots Ball celebrates the Lone Star State.

TOP: **Debbie Carter and Leslie Guidry watch the action.**

ABOVE: **Nancy Thompson, Reba White, Corra Wideman and Carolyn Mohair take a breather.**

LEFT: **Melinda Walker dances with her brother Billy Ray Walker, who kicks back with his red-topped boots.**

Photos by Andrea Bruce

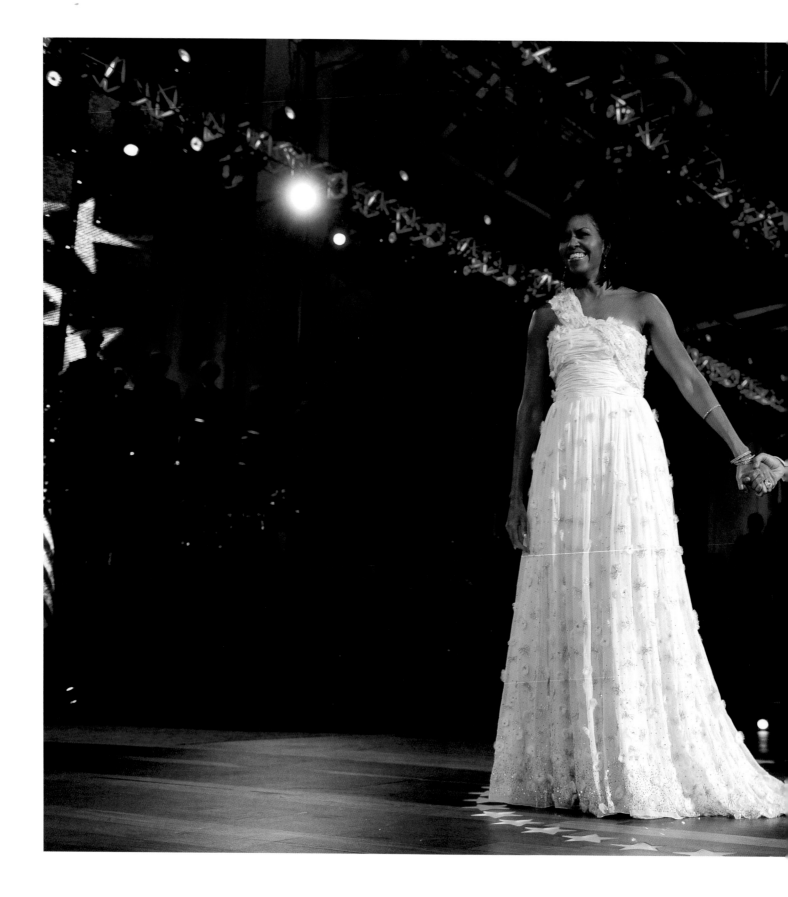

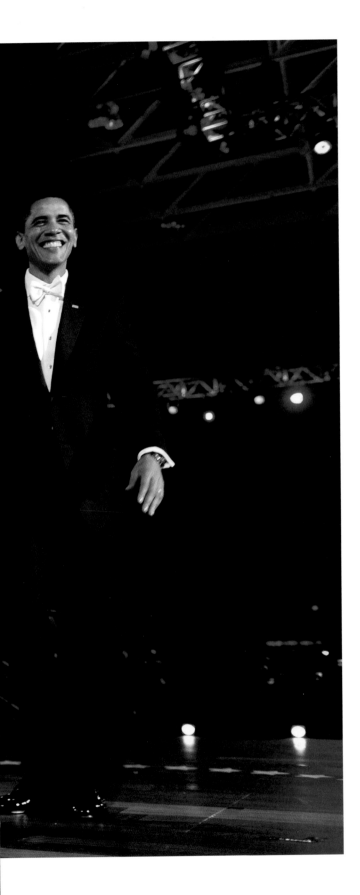

All Eyes on The Moment

Long before a frigid dawn, the multitudes began streaming to the National Mall, seeking the perfect spot to witness the history that would take place at 12:04 p.m. The inauguration of Barack Hussein Obama as the nation's 44th president was attended by perhaps the largest audience ever to assemble in Washington.

The oath, the speech, the fit young leader and his wife striding confidently down the parade route — the day, of course, was about him. But more than that, it was about everyone out there in the crowds that stretched from the Capitol to the Lincoln Memorial: every person with an individual story, a set of meanings and reference points for a moment many thought would never happen in their lifetimes.

That evening, the new first couple basked in the euphoric response as "Hail to the Chief" announced their arrival at the first of 10 inaugural balls. Obama, ever the community organizer, refused to let the moment pass without a quick entreaty: "We are going to need you, not just today, not just tomorrow, but this year, for the next four years and who knows after that, because together, we are going to change America."

Taking the floor at the Neighborhood Ball at the Washington Convention Center.

Photo by Richard A. Lipski

The morning of the inaugural, public transportation was the way to go.

*Right photo by Michael Williamson;
Below and opposite page by Dayna Smith*

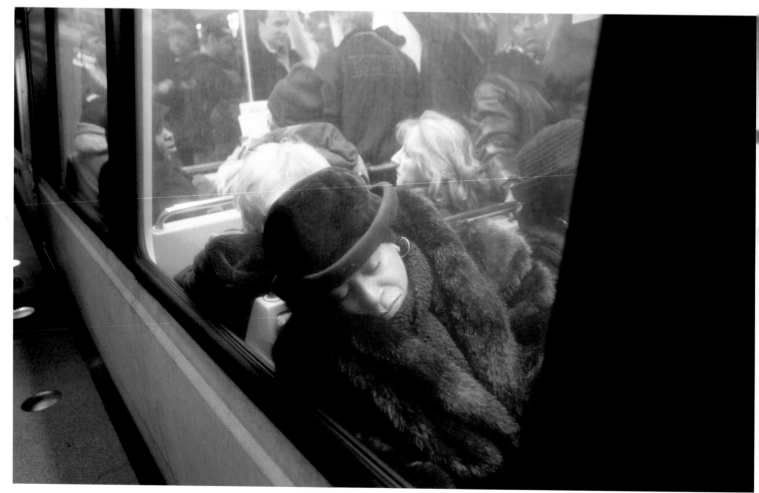

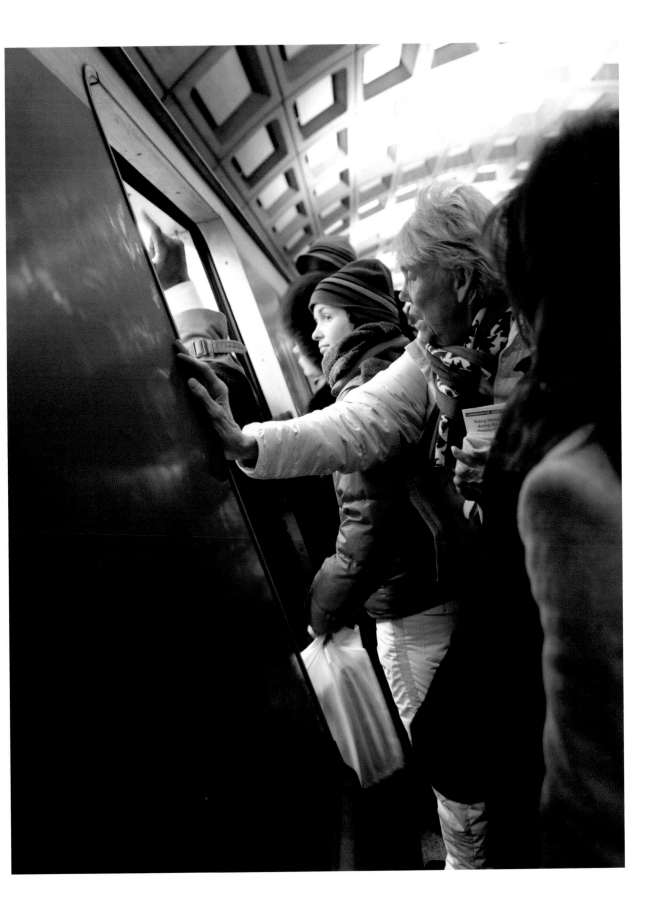

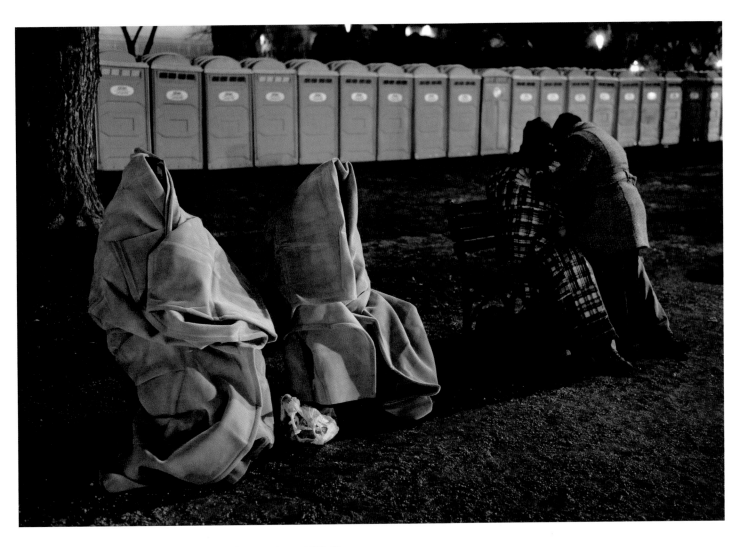

LEFT: **Keeping warm at 4 a.m. on the National Mall.**

ABOVE: **Bundled on benches are, from left, Terry Lackey, Christine Robinson, Joshua Rubin and Alexandra Ramos.**

Photos by Michael Williamson

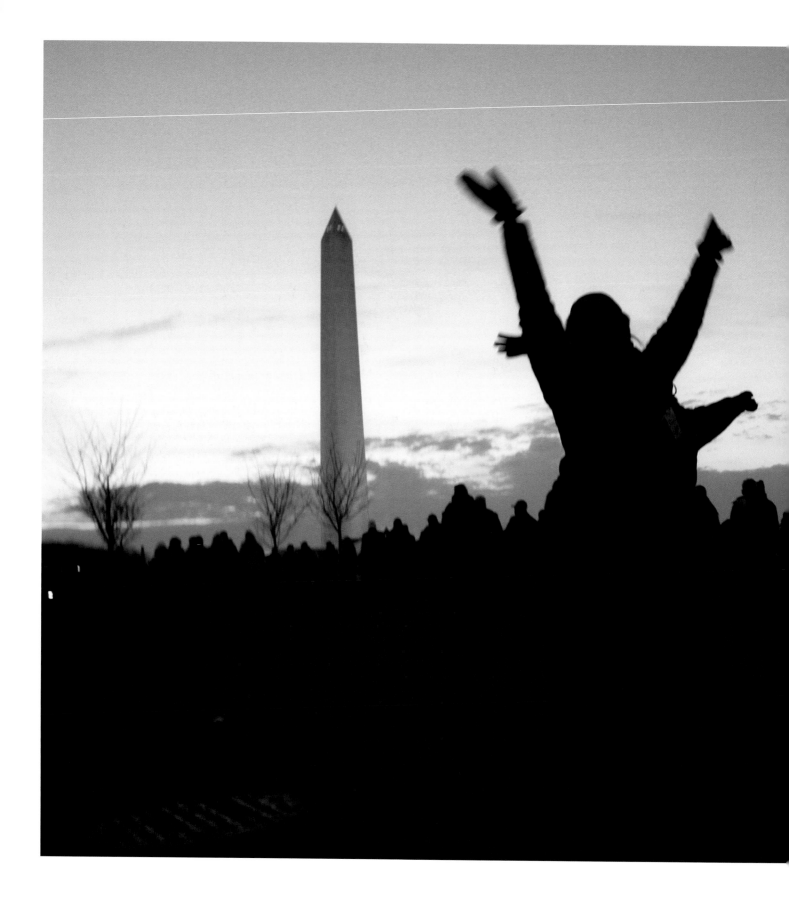

ABOVE: **Palmer Reisling of Cincinnati finds a prime spot for his poster.**

LEFT: **Jubilation as the sun rises at the Washington Monument.**

Above photo by Michael Williamson; left by Carol Guzy

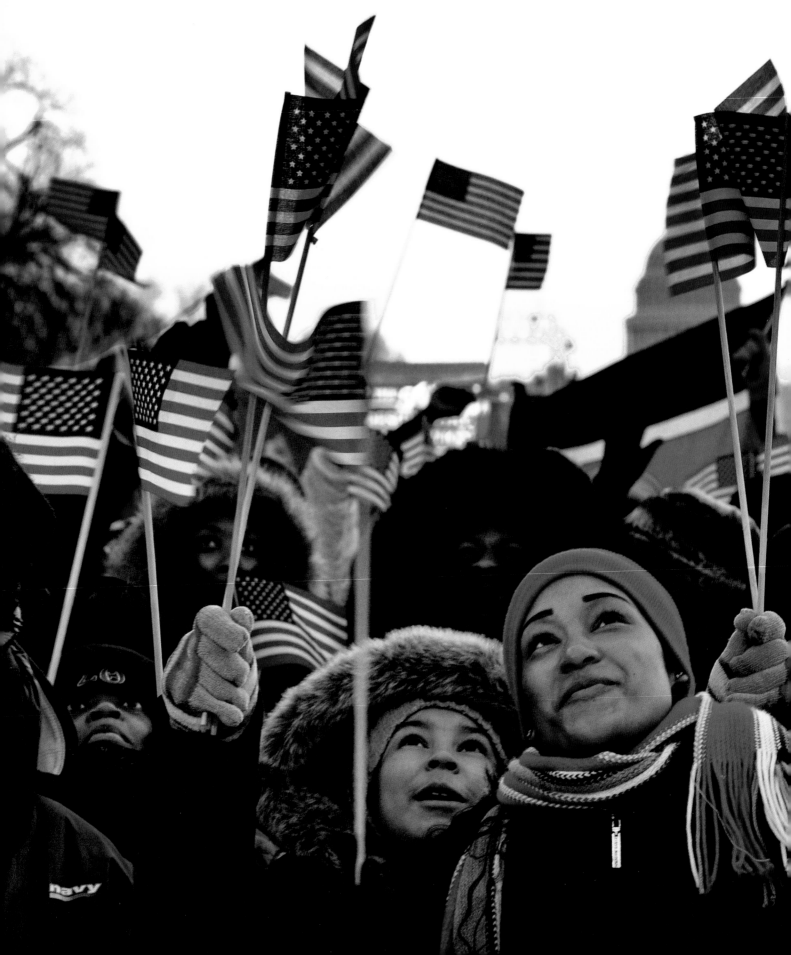

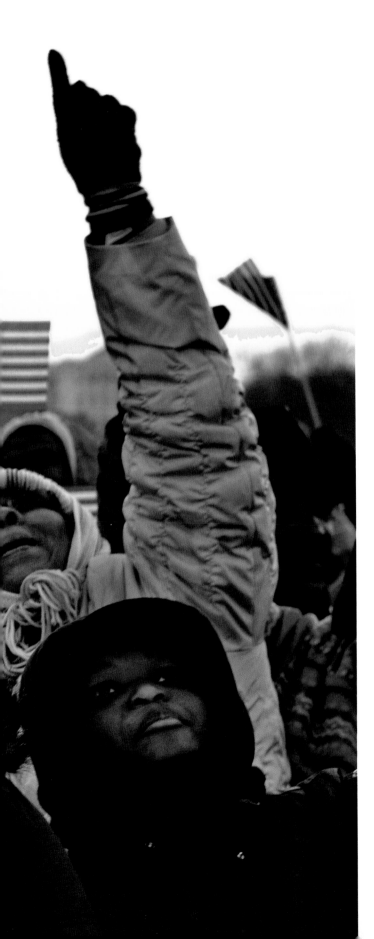

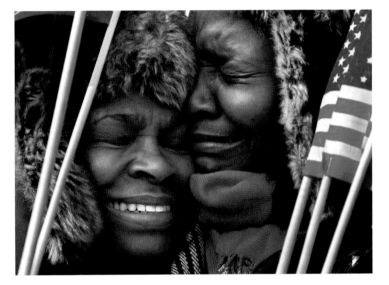

ABOVE: **Lorraine Bias, left, and her sister, Rochelle Bias, react as Obama is sworn in.**

LEFT: **Watching a television camera pass overhead on the National Mall.**

Above photo by Lucian Perkins; left by Michael Williamson

Leaving St. John's Church at Lafayette Square after attending a service before the swearing-in ceremony.

Photo by Ricky Carioti

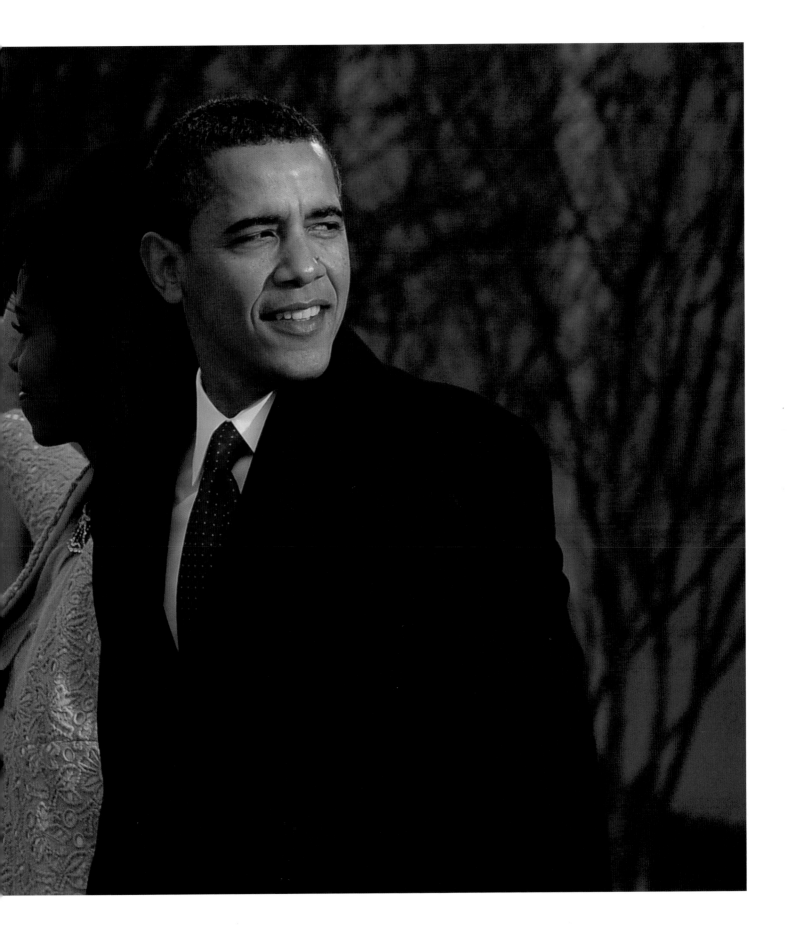

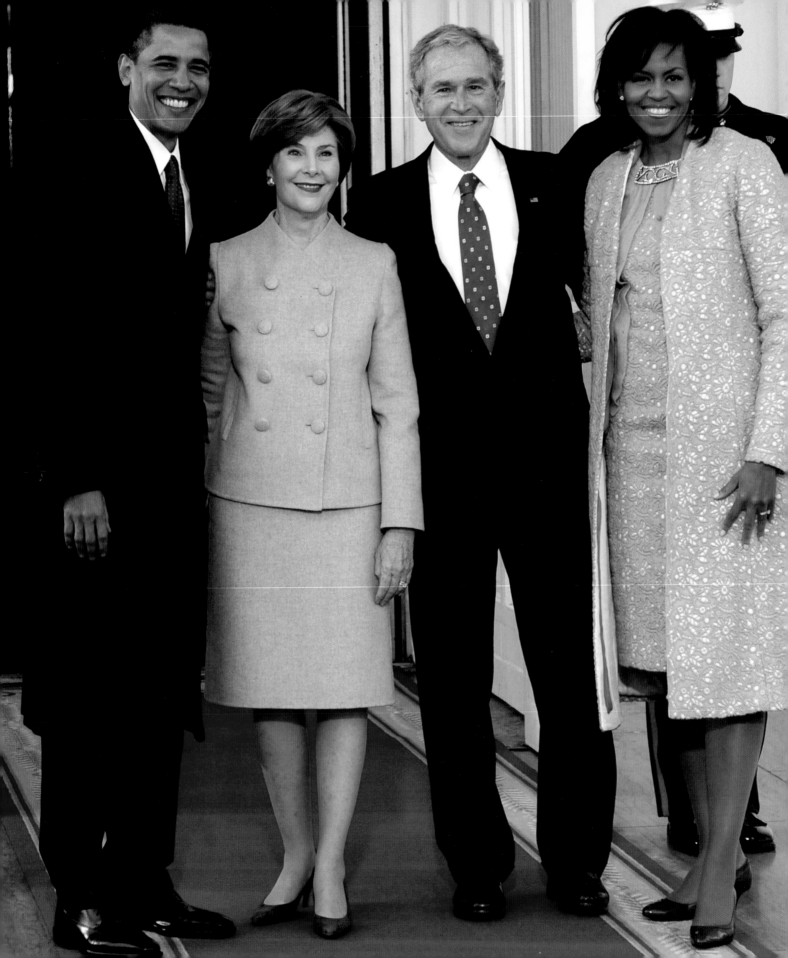

LEFT: **Bush on the way to the ceremony.**

BELOW: **Biden follows as Vice President Dick Cheney is wheeled out of the north portico after pulling muscles in his back while moving boxes.**

Photos by Linda Davidson

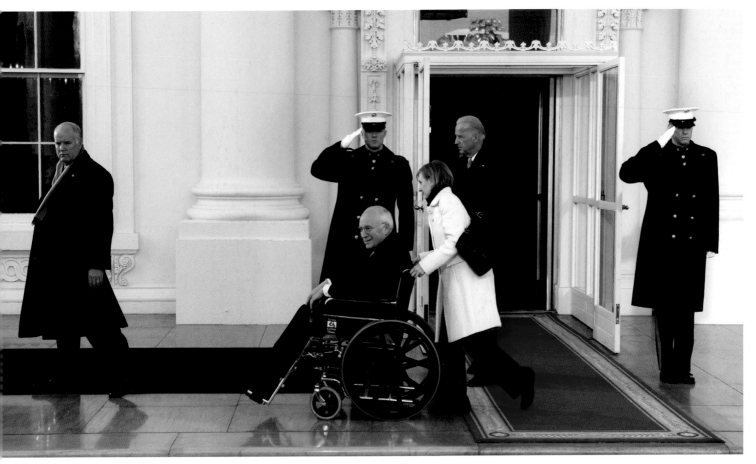

BEFORE THE SWEARING-IN CEREMONY, President and Laura Bush welcomed President-elect and Michelle Obama to the Blue Room of the White House for coffee. The Cheneys and Bidens joined them. Michelle Obama brought a gift for Laura Bush and, following recent tradition, Bush left a private note for Obama in the top drawer of the Resolute Desk in the Oval Office.

ESTIMATING A HEAD COUNT for events on the National Mall has long been a politically touchy exercise, but two things are clear about the size of the crowd downtown for Tuesday's inauguration: First, although some experts described it as high, the official estimate released by Washington officials was 1.8 million, a figure that would make the gathering the largest ever on the Mall. Second, from atop the Washington Monument, we look like ants.

Photo by Gerald Martineau

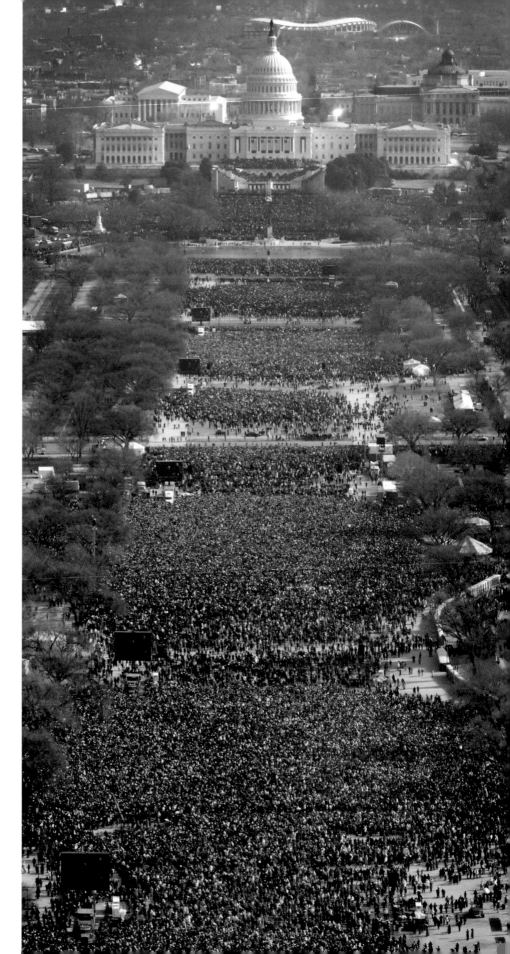

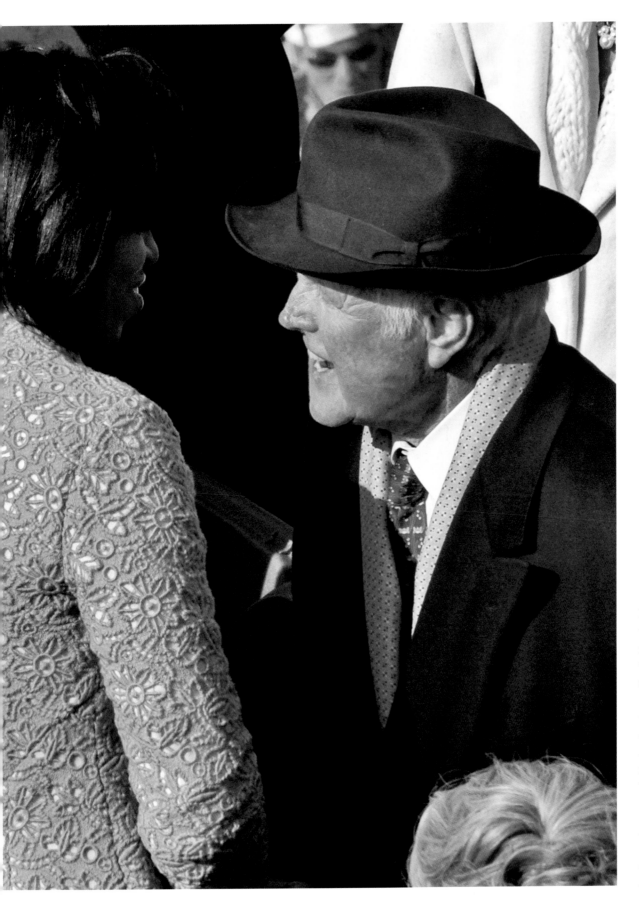

Sen. Edward M. Kennedy greets the incoming first lady at the swearing-in ceremony. Kennedy, ill with brain cancer, suffered a seizure later in the day, but was alert and talking to doctors at the hospital.

Photo by Bill O'Leary

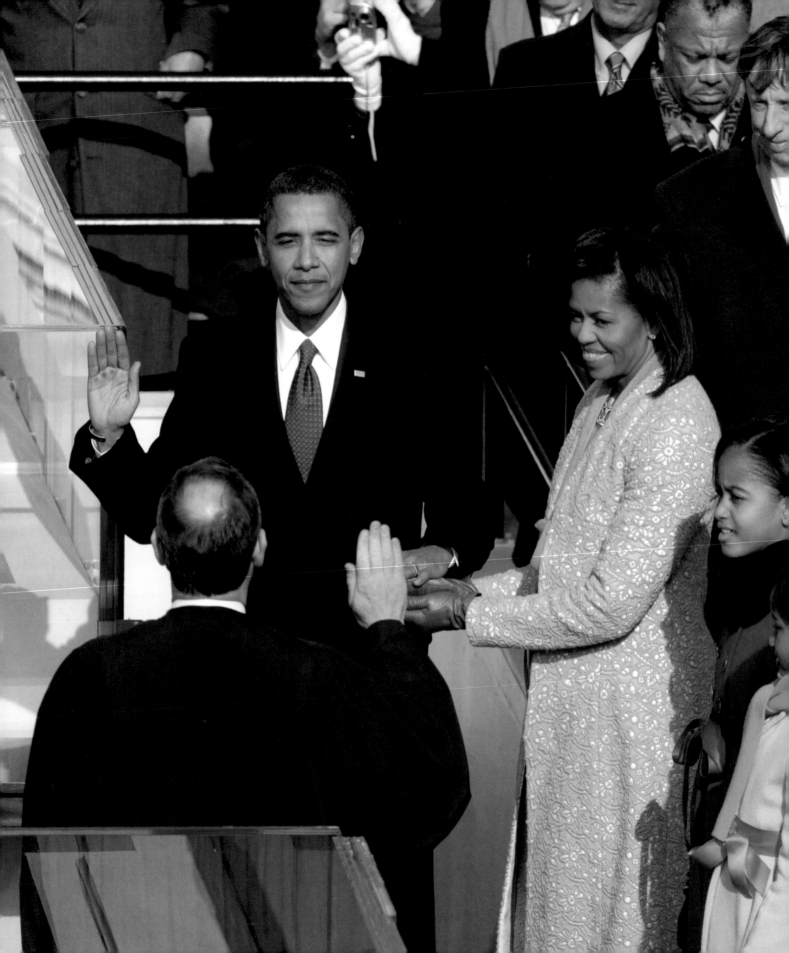

Administering the oath becomes a verbal struggle when the two men trip over each others' words. After Chief Justice John G. Roberts Jr. puts the word "faithfully" in the wrong place in his prompt, Obama pauses to allow him to repeat the words in the correct order, but then recites them in the wrong order.

The men meet in the White House Map Room the following day to re-administer the oath, in what the White House counsel calls "an abundance of caution."

Photo by Jonathan Newton

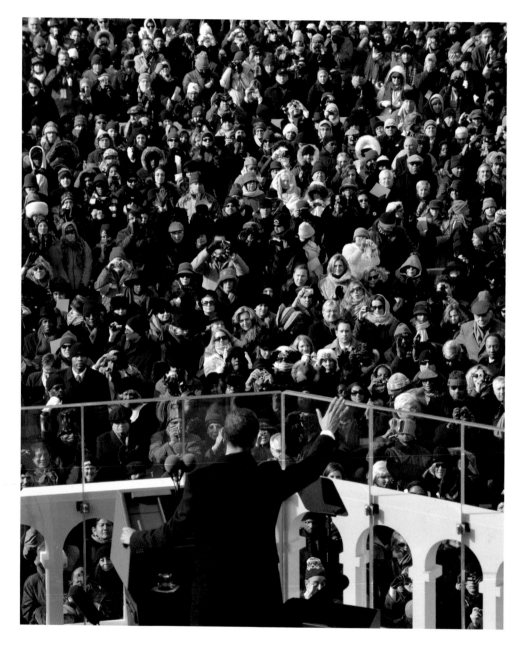

ABOVE: **Obama concludes his inaugural address.**

OPPOSITE PAGE: **Dad gets a thumb's up after the swearing-in.**

Photos by Bill O'Leary

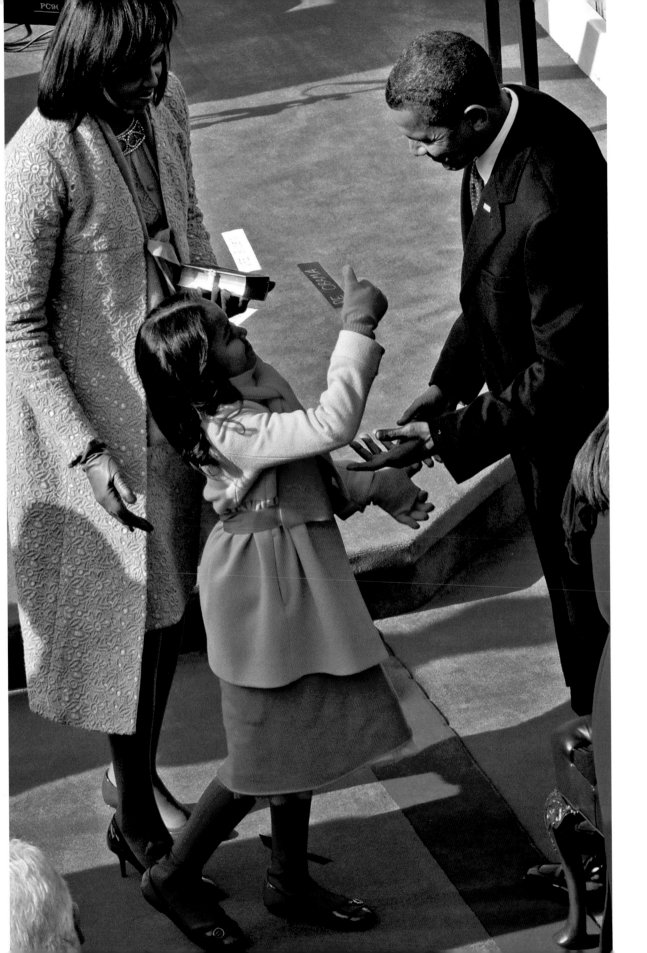

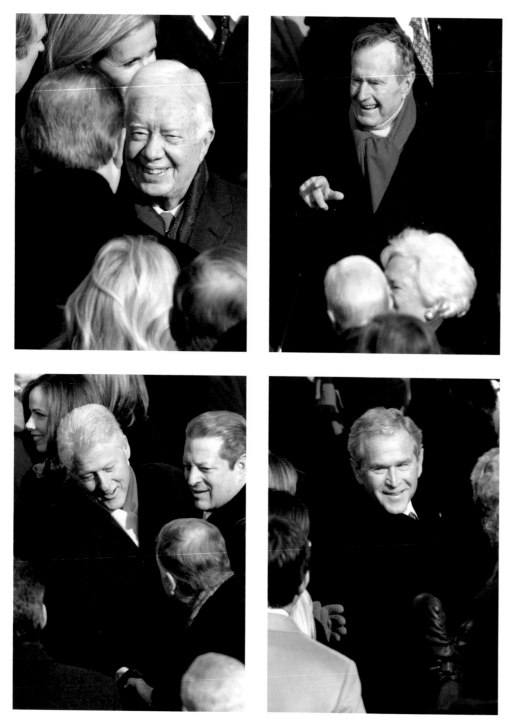

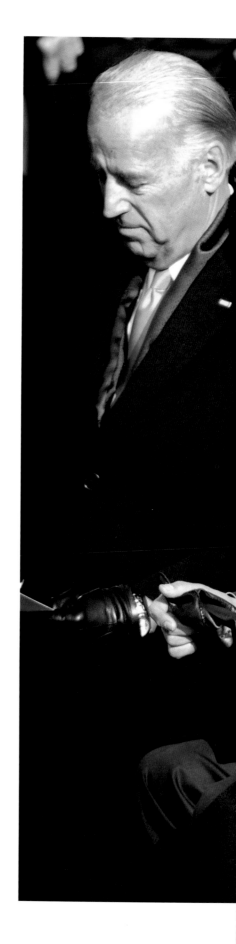

ABOVE, clockwise from top left: **Former presidents Jimmy Carter, George H.W. Bush, George W. Bush, Bill Clinton.**

RIGHT: **The outgoing and incoming presidents share a laugh as the swearing-in ceremony begins.**

Photos by Jonathan Newton

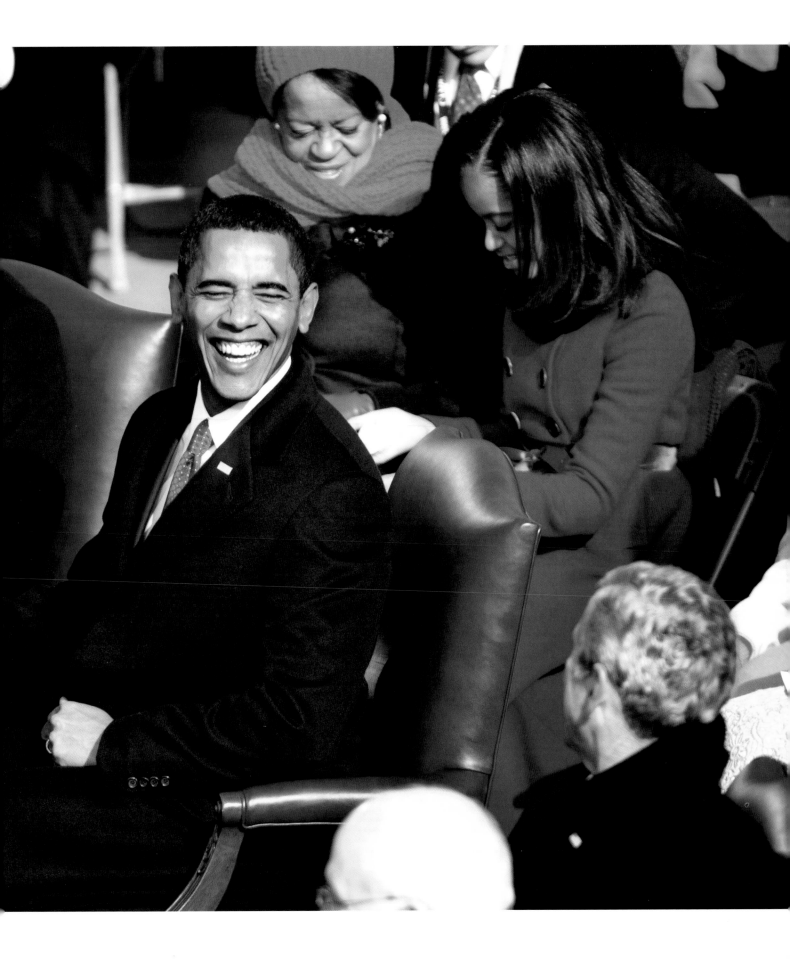

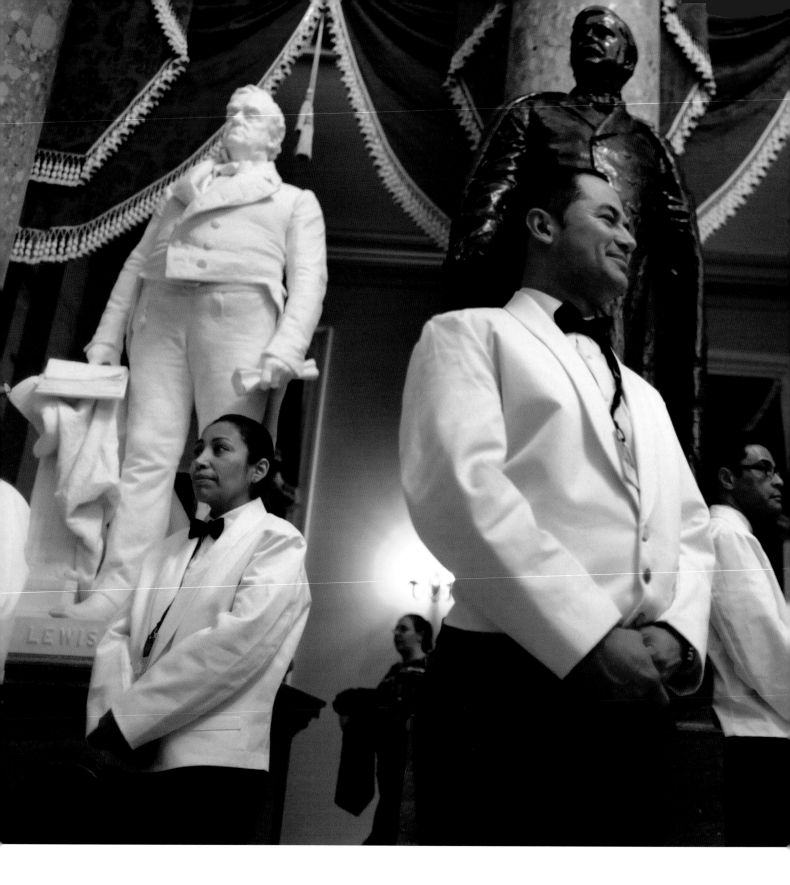

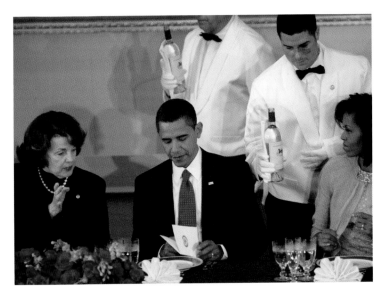

TOP: **As chairwoman of the Joint Congressional Committee on Inaugural Ceremonies, Sen. Dianne Feinstein gets a favored seat.**

LEFT: **Waiting to serve the inaugural luncheon are, foreground from left, Patricia Motto, Jorge Saavedra and Gonzalo Padillo.**

Photos by Melina Mara

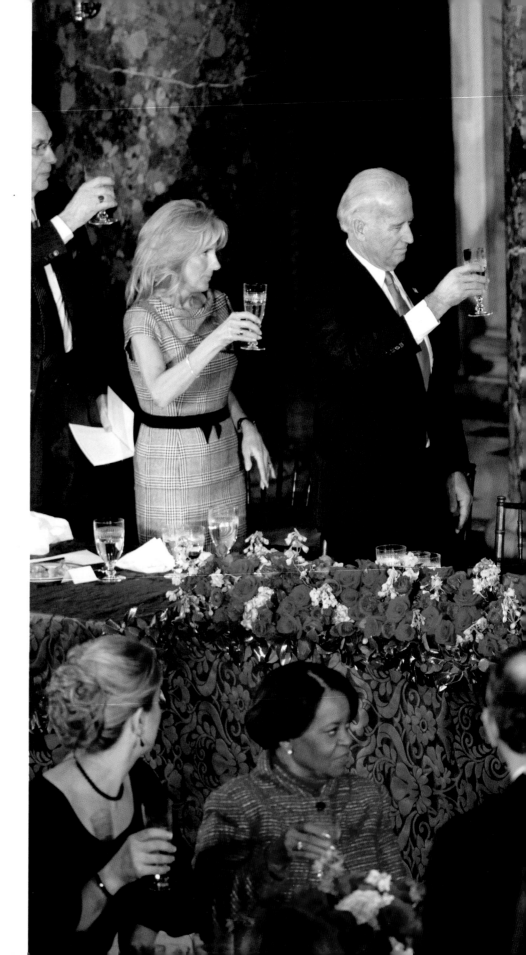

A toast to the new president at the traditional inaugural luncheon in the Capitol's Statuary Hall.

Photo by Melina Mara

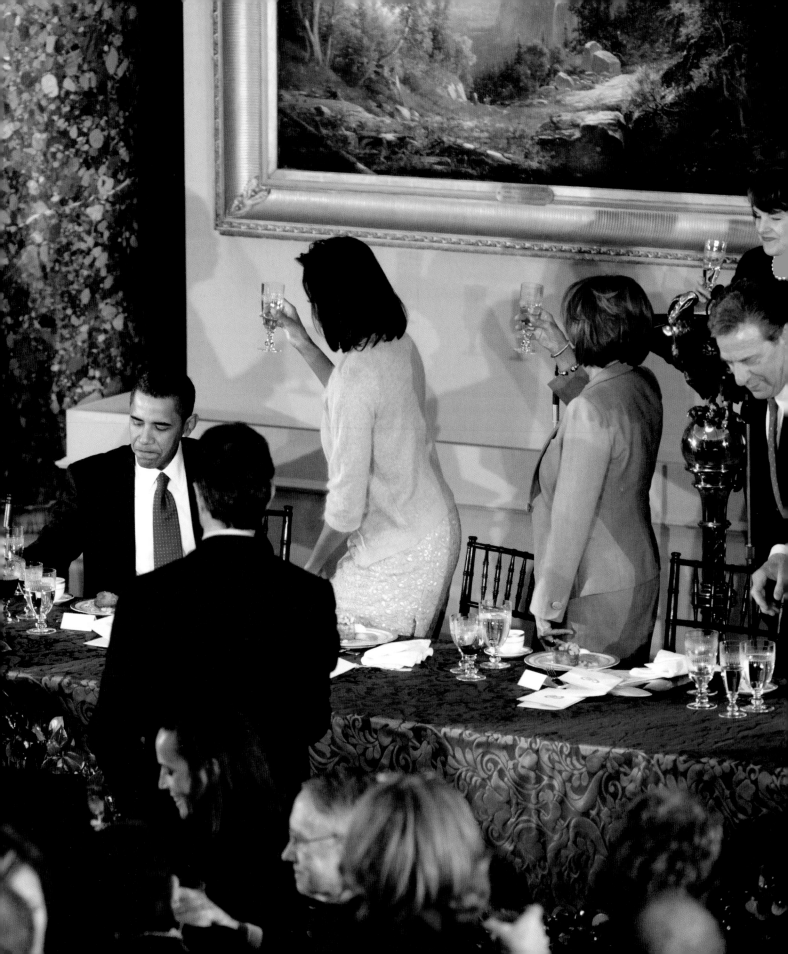

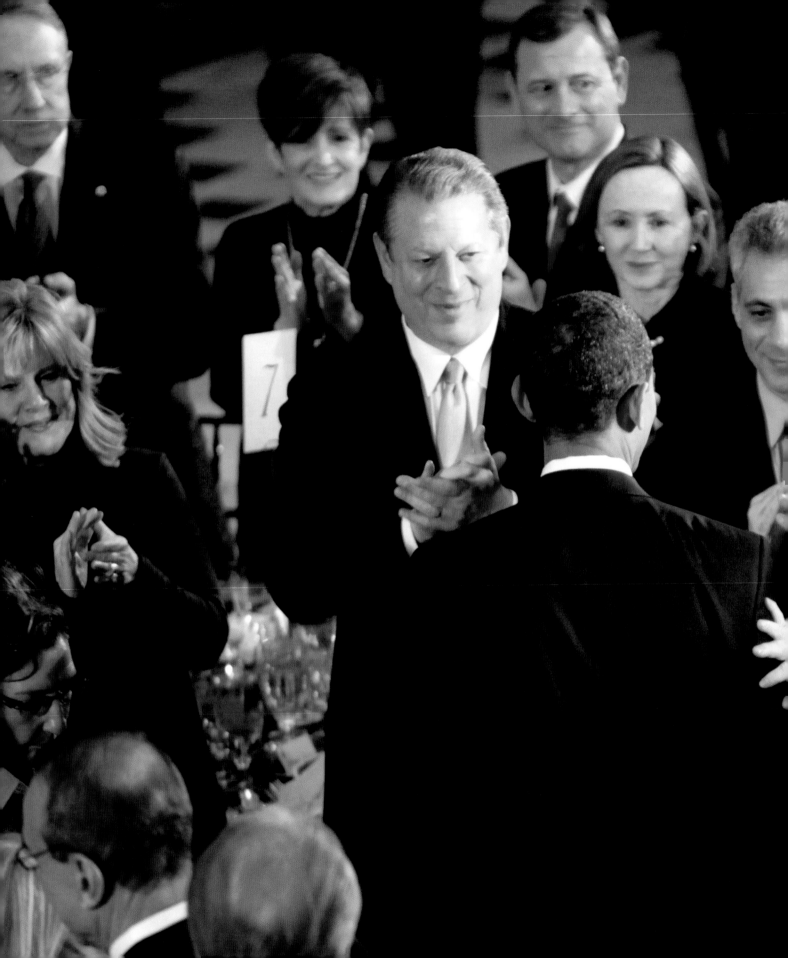

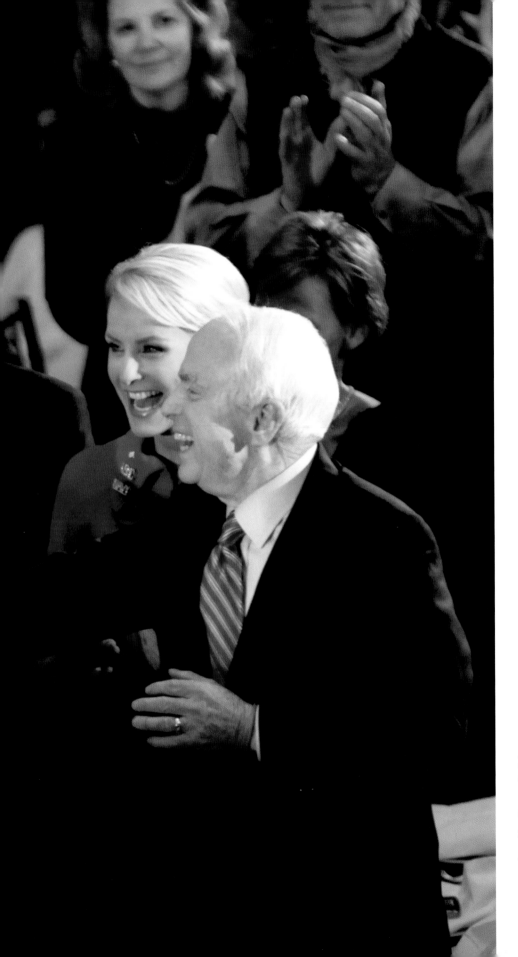

Former vice president Al Gore, Chief of Staff Rahm Emanuel, Sen. John McCain and his wife, Cindy, join a rousing welcome for the president.

Photo by Melina Mara

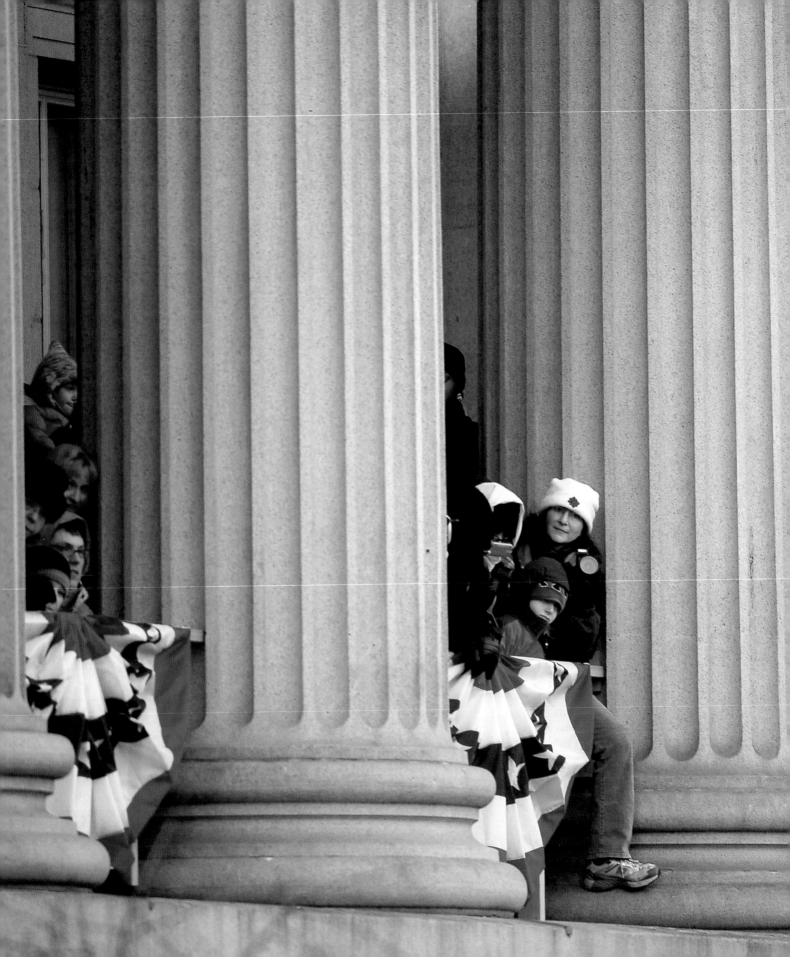

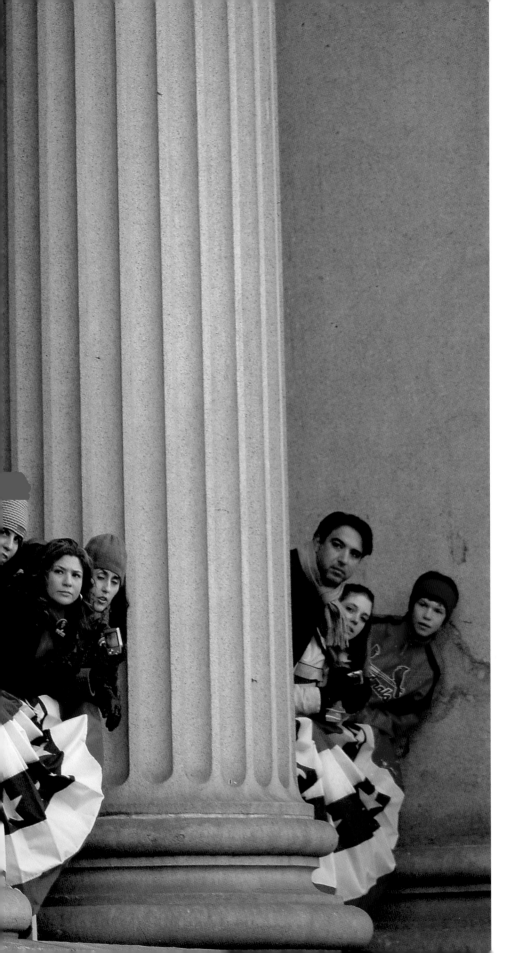

People peek around the pillars of the Treasury Building to watch the parade.

Photo by Preston Keres

ABOVE: **Alex Gooden of the Golden Eagle marching band from Trumbull High School in Connecticut waits for his buddy at the parade staging area.**

OPPOSITE PAGE: **Josyln Walker, 16, left, and Gilbert Labardy, 17, students from the New York Military Academy in Cornwall, are ready for the call to assemble for the parade, amid the many images showing the Obama spirit.**

Above photo by Susan Biddle; opposite page, clockwise from top left: photos by Mark Gail, Carol Guzy, Gail, Biddle and Michael Williamson

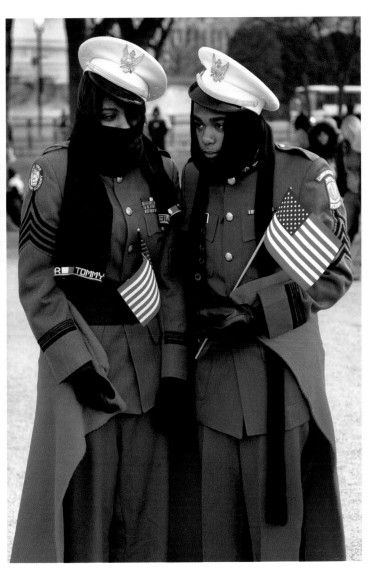

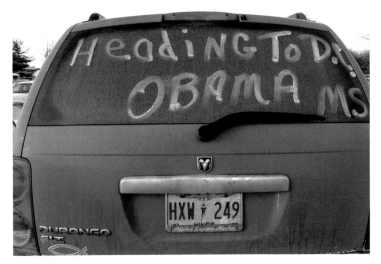

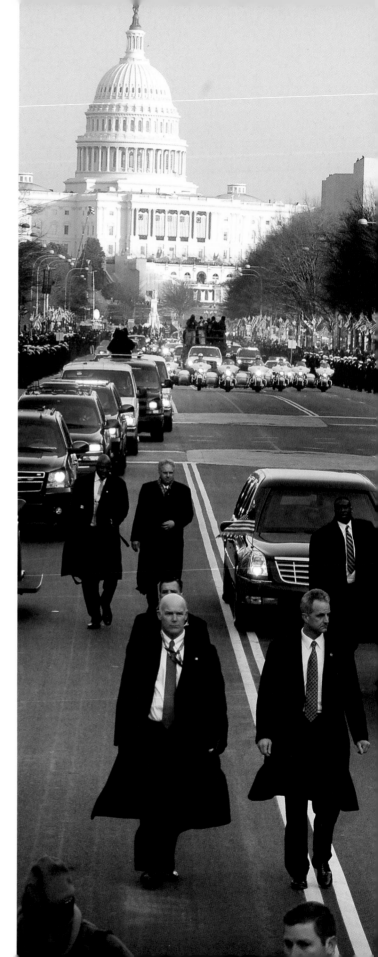

Walking part of the parade route.

Photo by Preston Keres

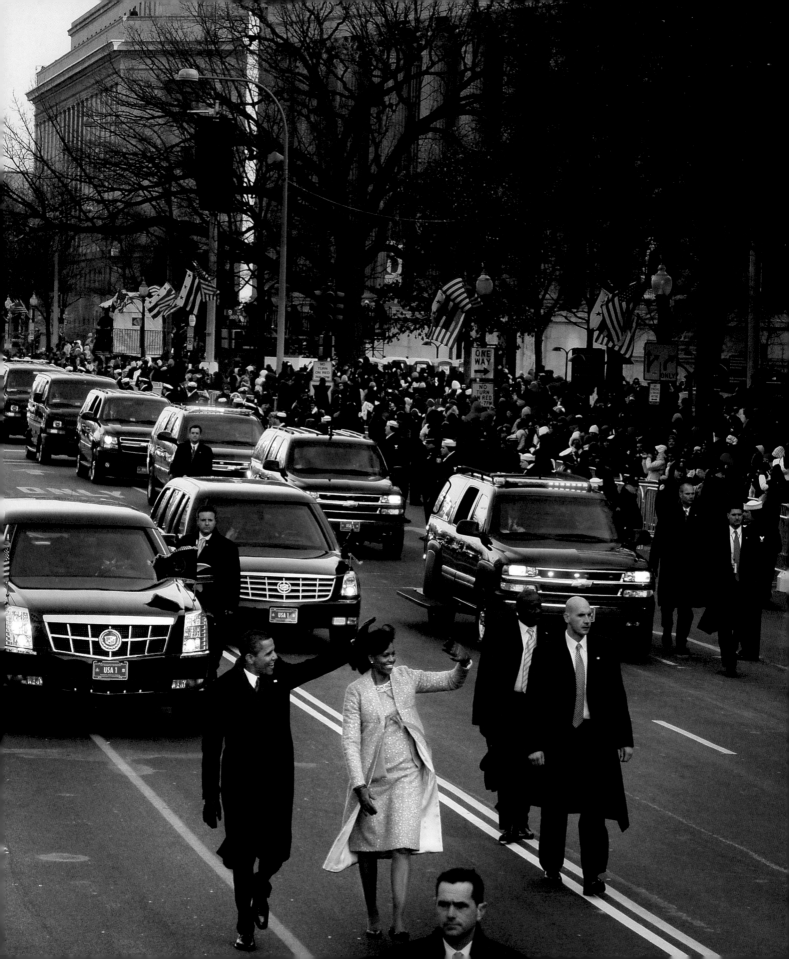

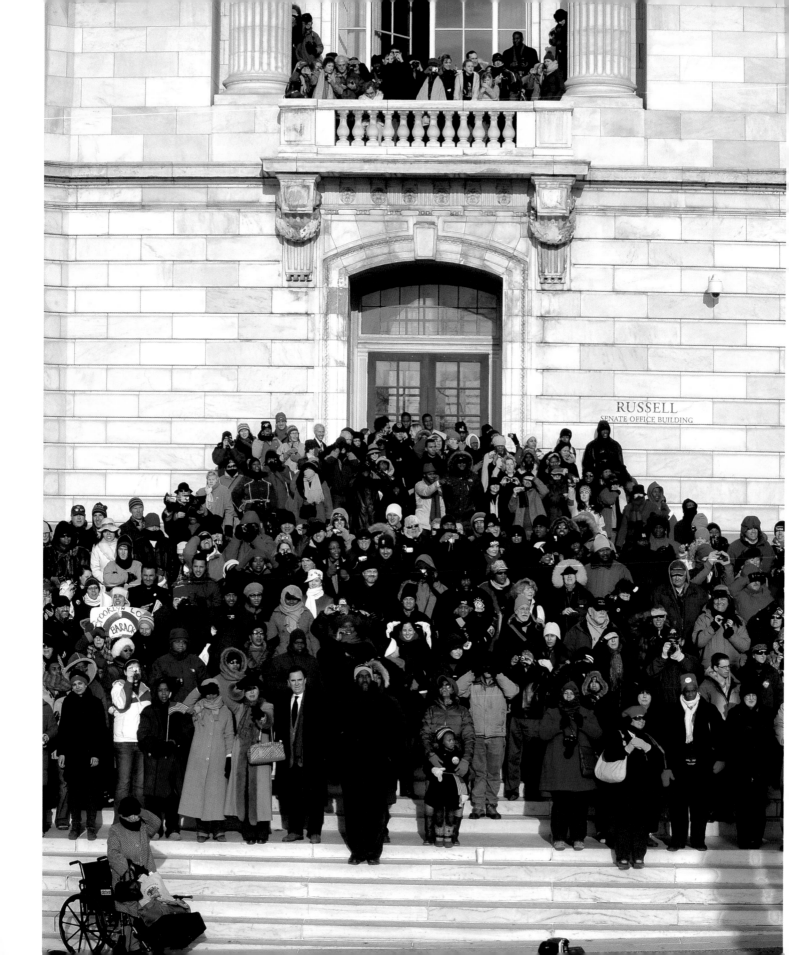

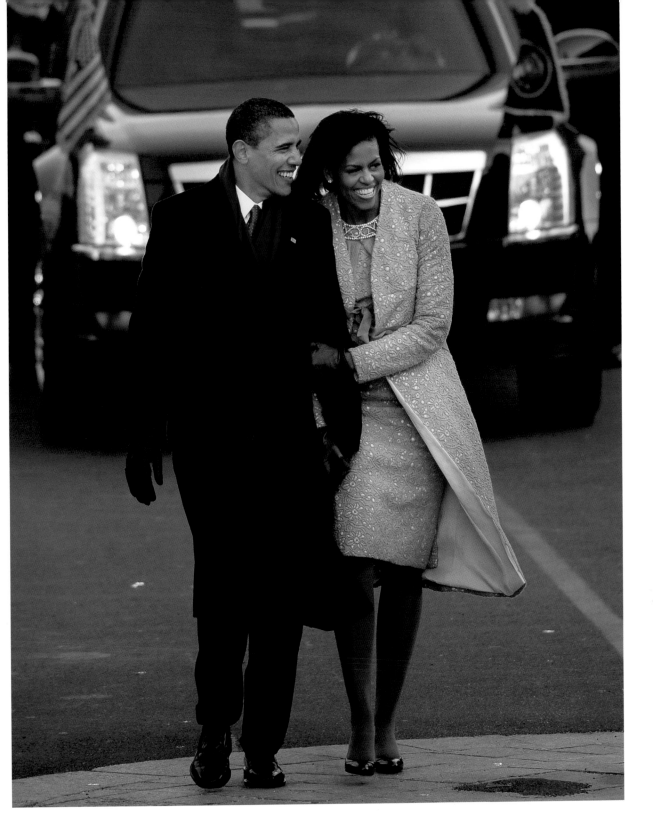

LEFT: **Onlookers jam the steps and balcony of the Russell Senate Office Building, waiting for the new president to go by.**

ABOVE: **To the delight of the crowd, they're out of the limousine.**

Photos by Preston Keres

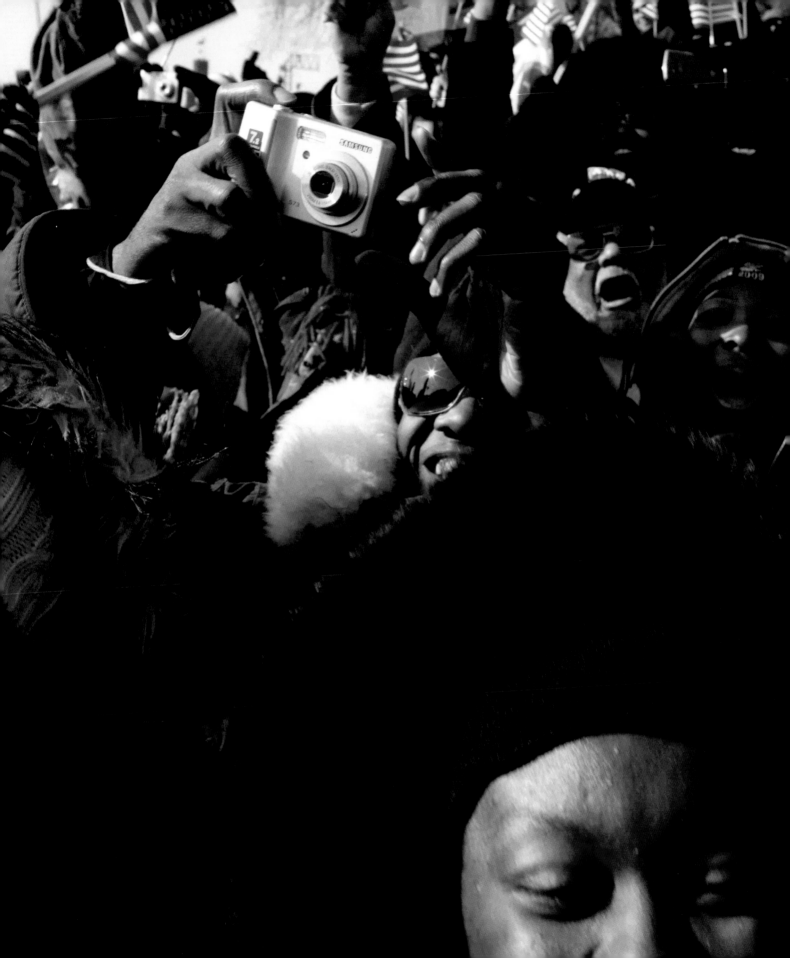

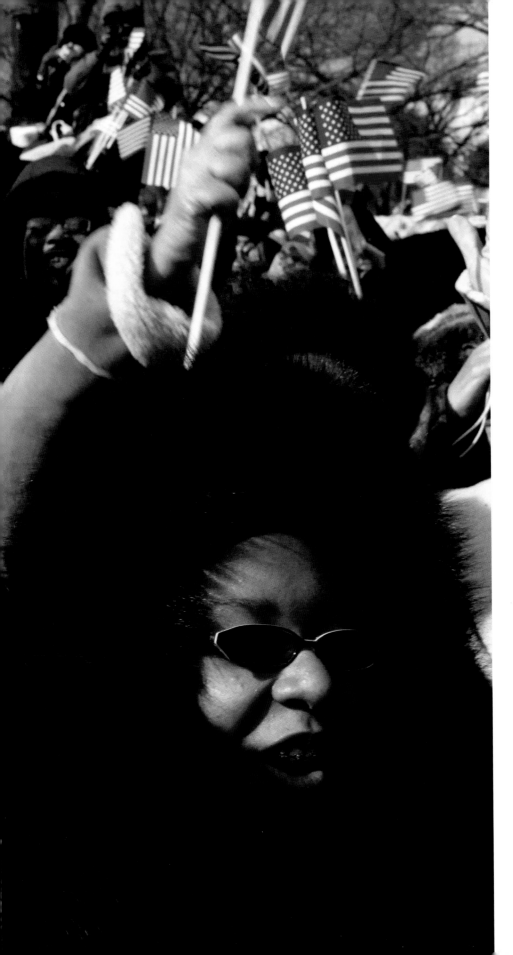

The moment makes them want to shout.

Photo by Dominic Bracco II

Spectators cram windows along the parade route, hoping for a glimpse of the president.

Top left and bottom right photos by Preston Keres; bottom left and top right by Katherine Frey

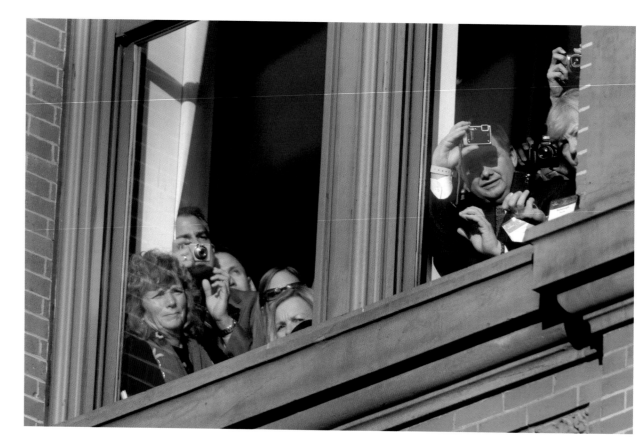

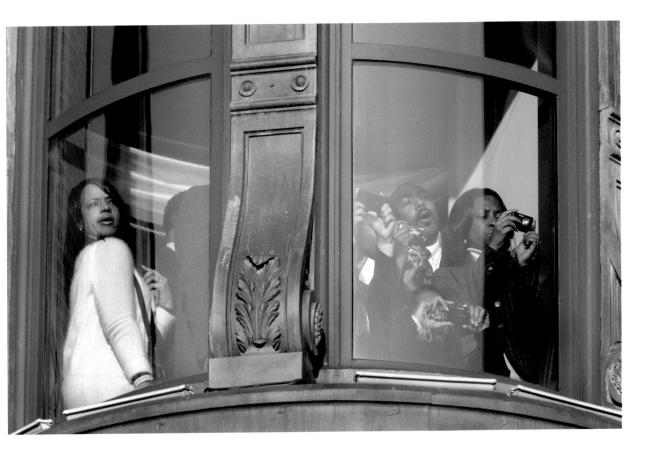

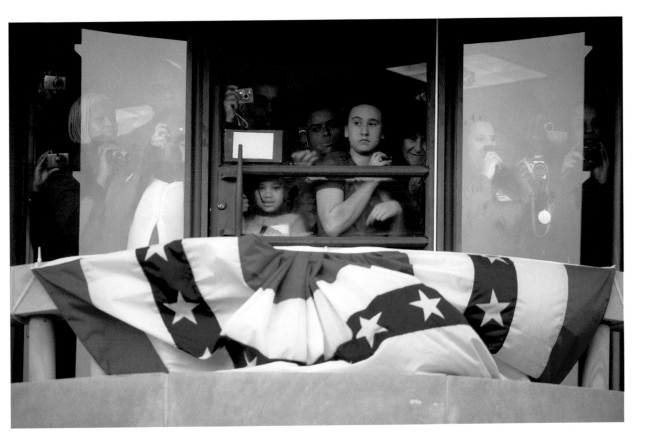

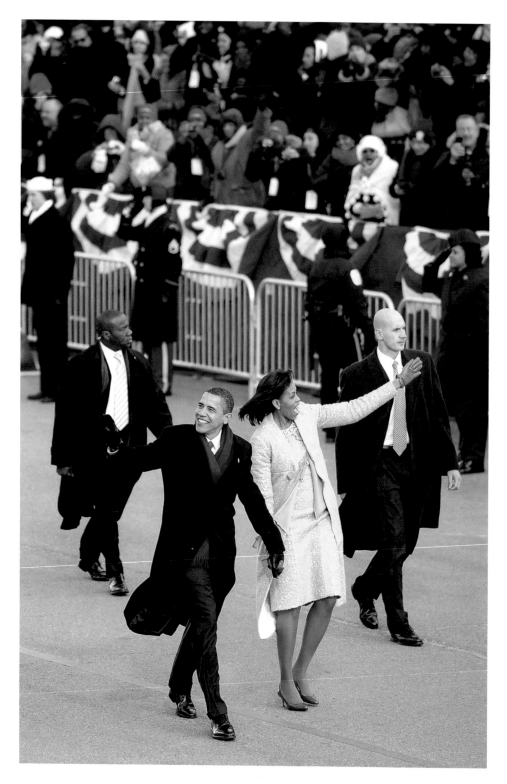

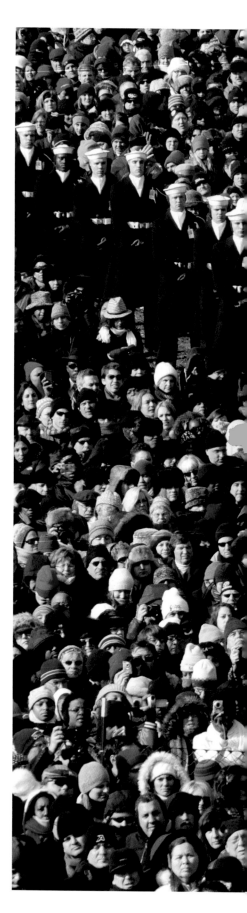

ABOVE: **The president and first lady electrify the crowd as they walk in front of the White House parade reviewing stand.**

RIGHT: **A row of sailors bisects the crowd on the National Mall.**

Above photo by John McDonnell; right by Bill O'Leary

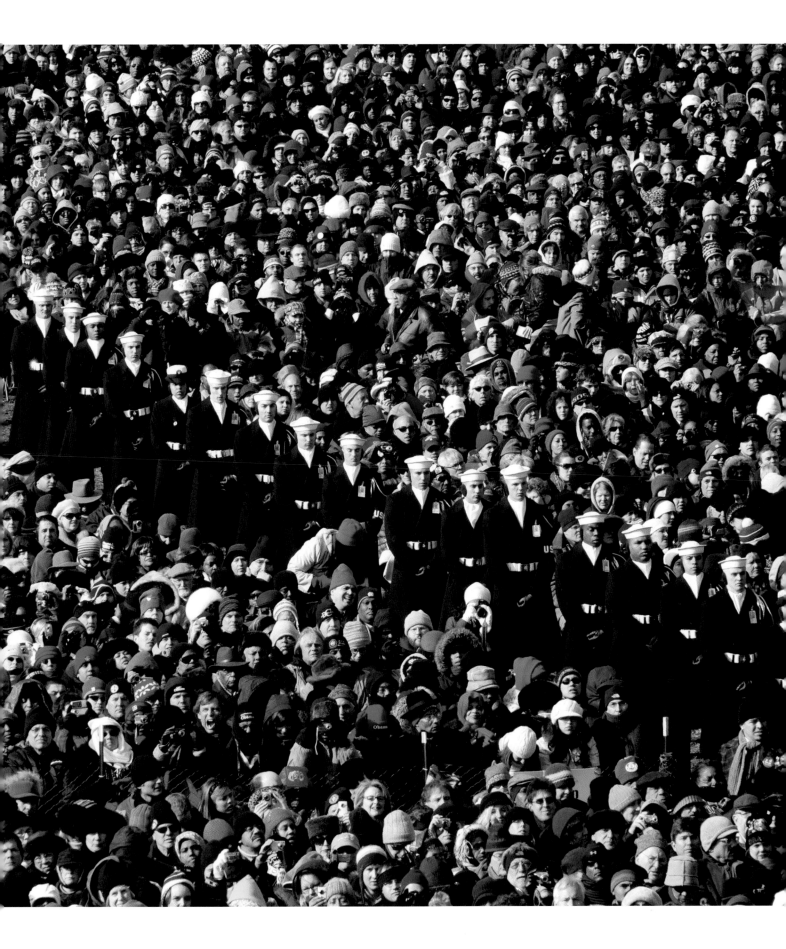

Showing the flag, clockwise from top: Concetta Weah of New Carrollton, Md.; Sharon Tomaski of Denver; Jill Dorsey of Atlanta; and Maria McGuire.

Photos clockwise from top by Dominic Bracco II, Carol Guzy, Lucian Perkins and Margaret Thomas

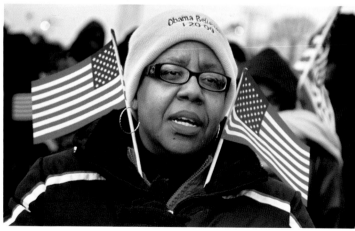

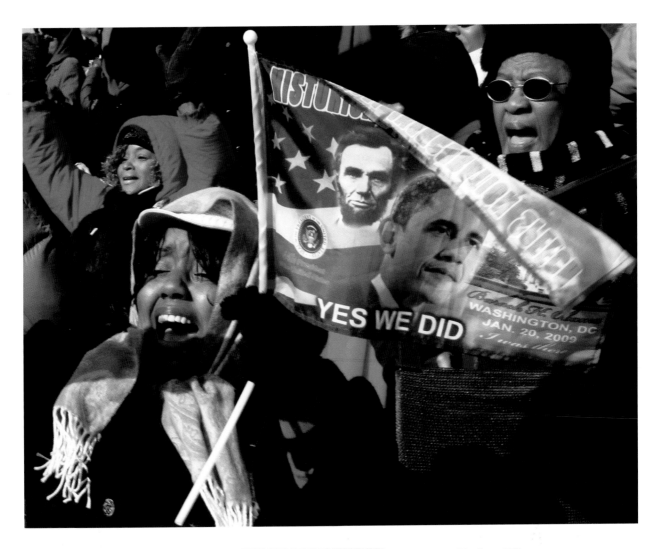

ABOVE: **Fatima Warren of Washington, D.C.**

LEFT: **Jessica McHugh and Tim McGregor of Cape Cod, Mass., foreground.**

Above by Carol Guzy; left by Lucian Perkins

127

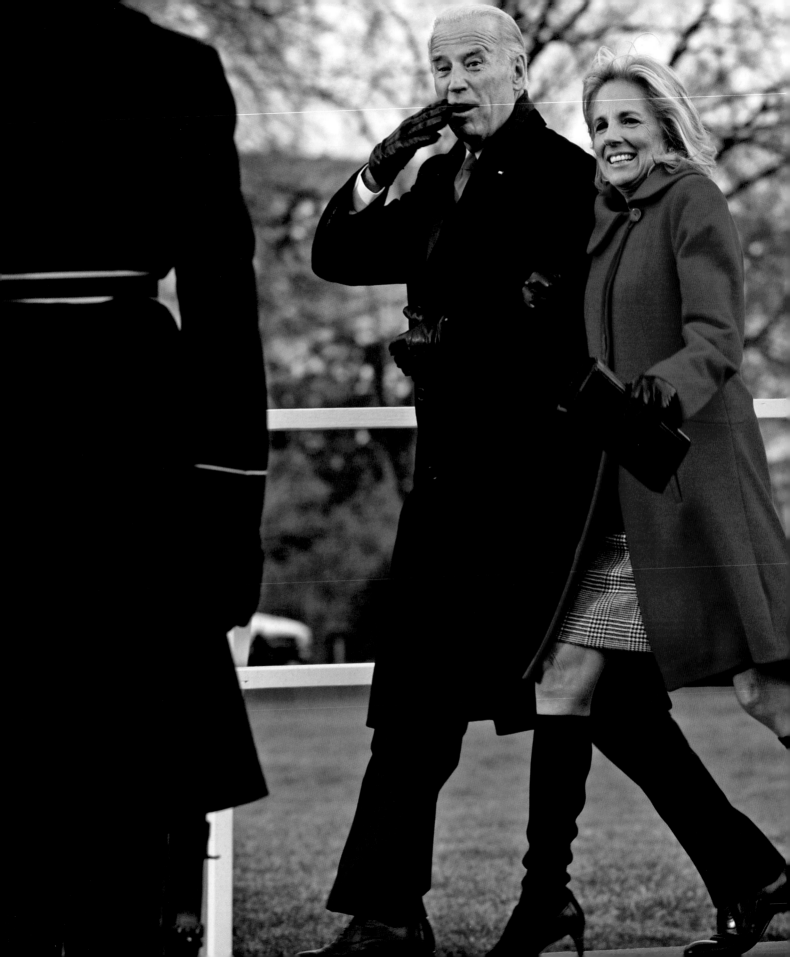

THE DAY MARKED A NEW chapter in Vice President Joseph R. Biden Jr.'s political life. Famous for riding Amtrak to work every morning from his home in Delaware when he was a senator, Biden stayed at a Washington hotel on the eve of his swearing-in. Now he spends most nights in Washington at the Naval Observatory, the traditional residence of the vice president.

LEFT: **The vice president and Jill Biden head across the White House north lawn to the parade reviewing stand.**

NEXT PAGE: **The Obamas walk to the reviewing stand.**

Photos by Linda Davidson

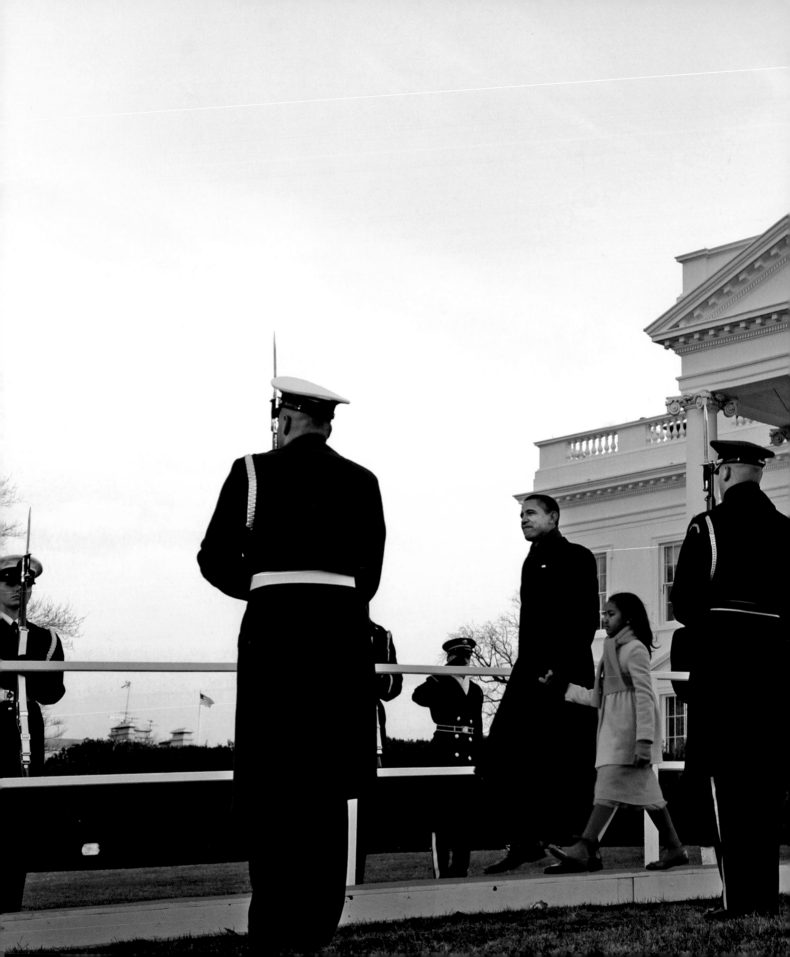

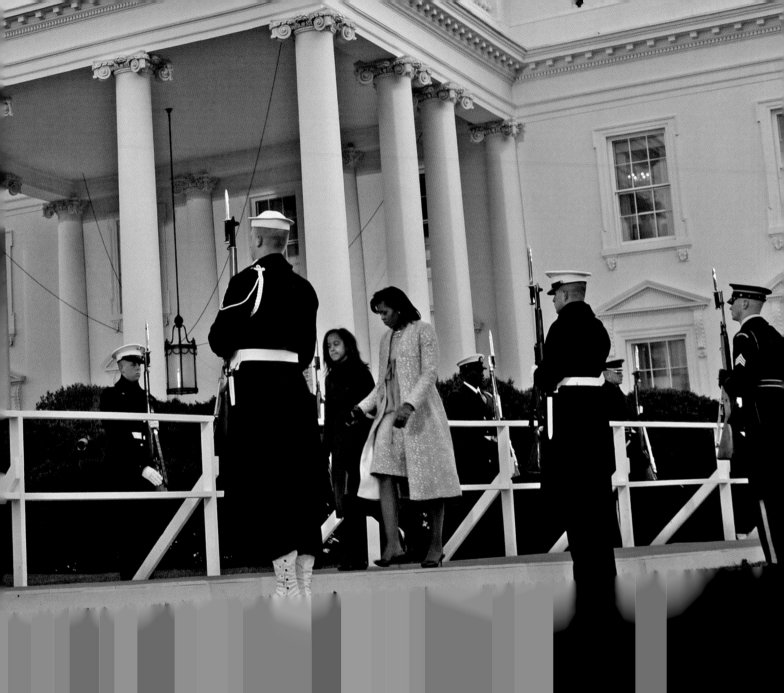

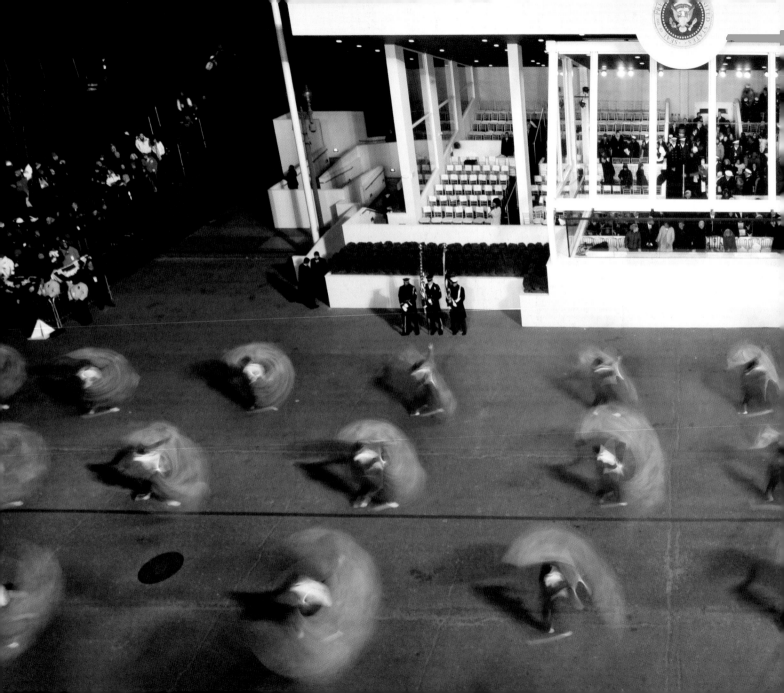

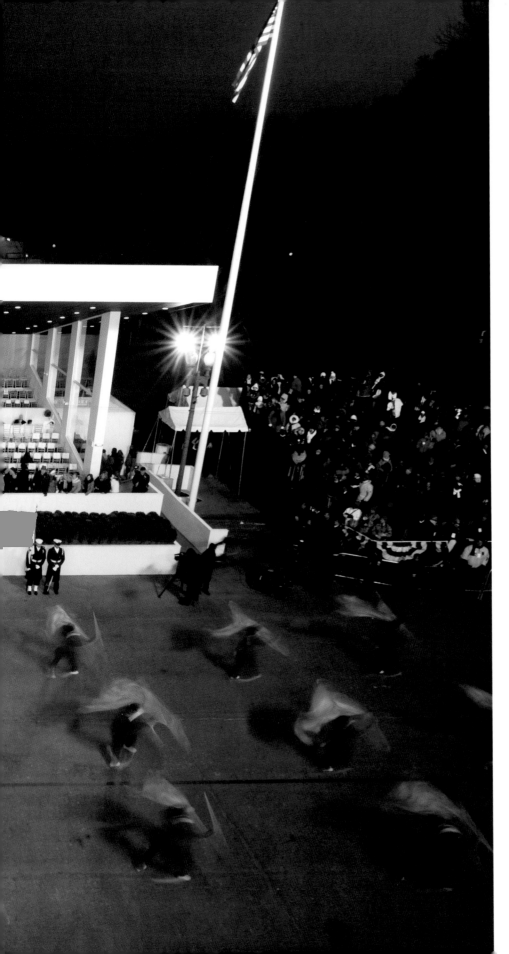

In front of the White House reviewing stand, flag twirlers are photographed with a slow shutter.

Photo by John McDonnell

133

Few linger in the freezing cold to watch the 10,000 parade marchers after the president has passed.

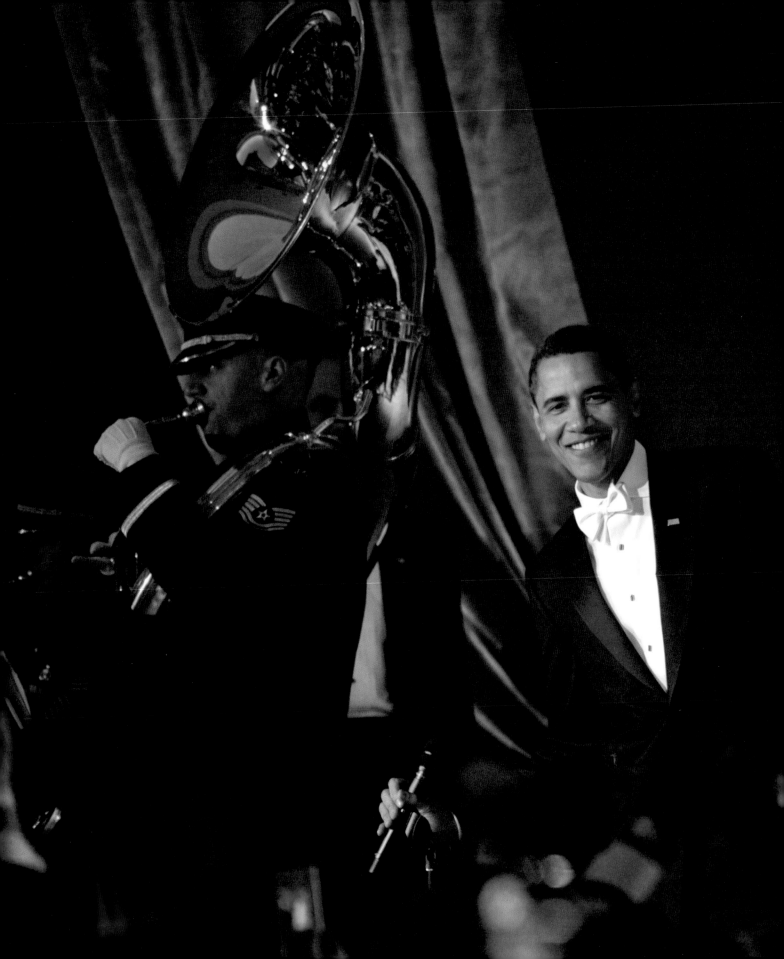

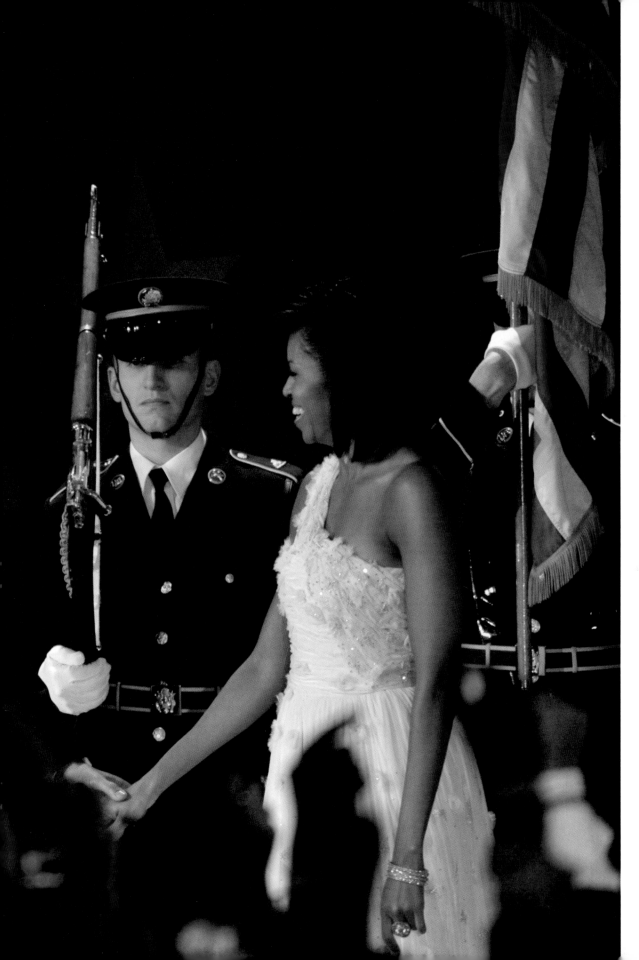

**At the
Youth Ball
at the
Washington
Hilton.**

*Photo by
Marvin Joseph*

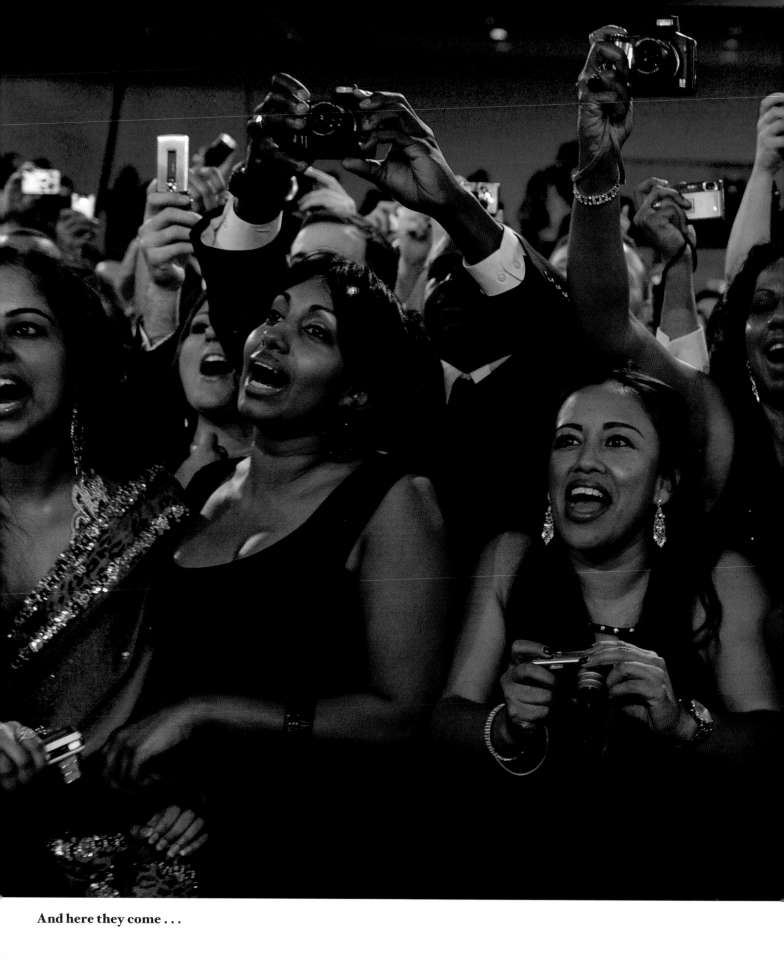

And here they come . . .

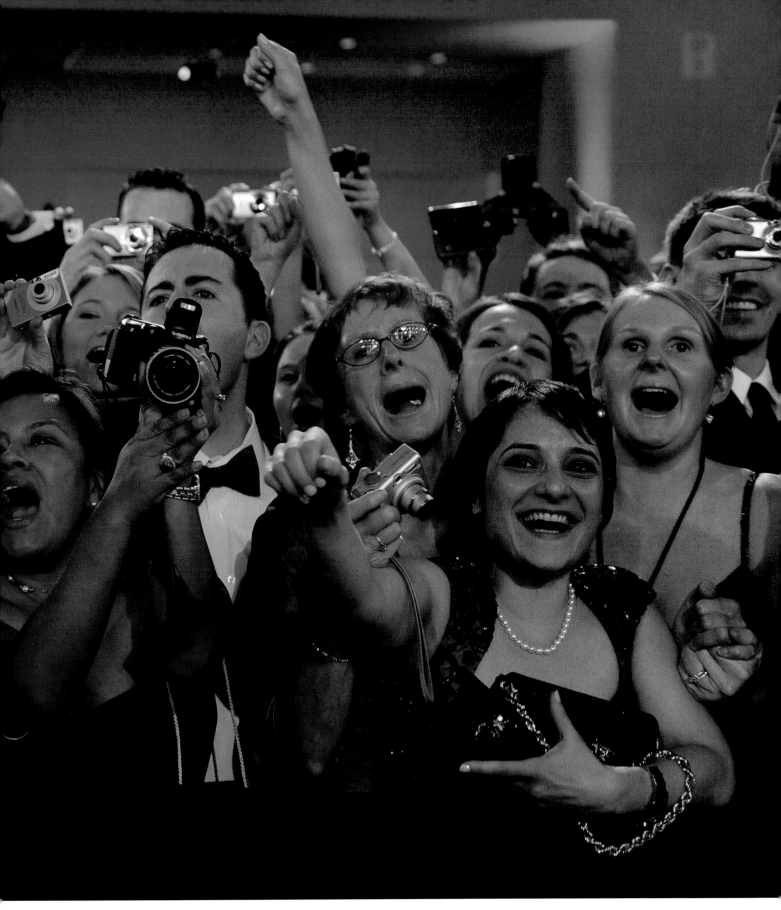

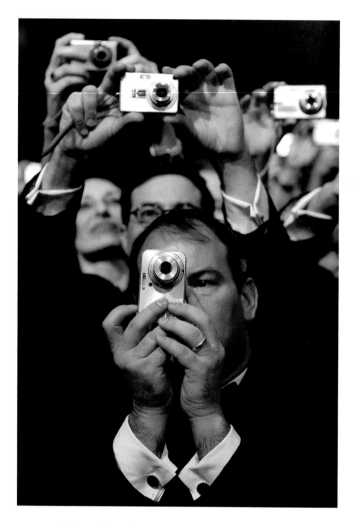

**Entering the Western Inaugural Ball
at the Washington Convention Center.**

Photos by Richard A. Lipski

MICHELLE OBAMA WEARS A FLOWING
ivory silk chiffon gown with a single strap,
embroidered with silver thread and
adorned with Swarovski crystal rhinestones.
The dress, by little-known New York designer
Jason Wu, 26, bares her arms and shoulders
and brings the first lady into the modern era,
in which glamour is defined by Hollywood
and the red carpet rather than
protocol and tradition.

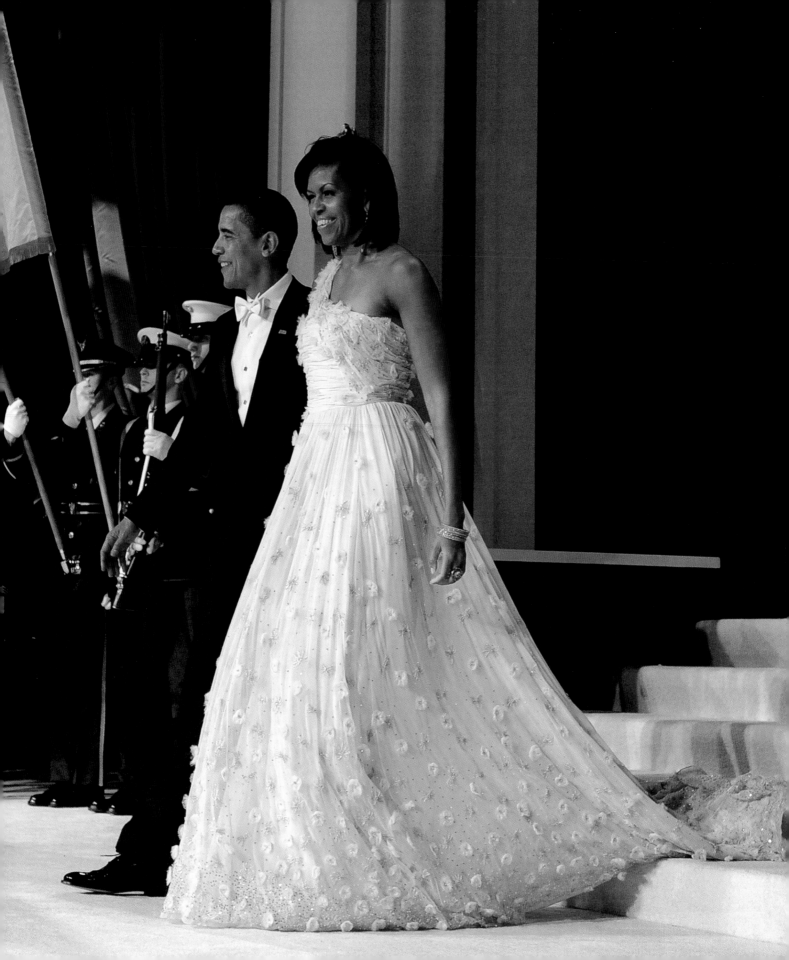

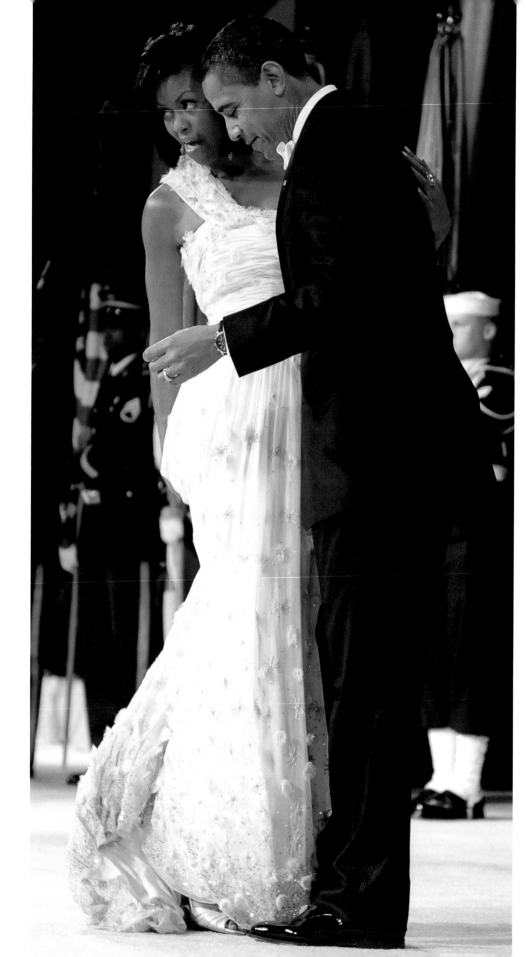

One, two, keep the gown away from his shoe.

Photos by Richard A. Lipski

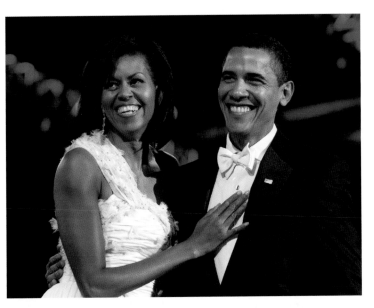

LEFT: **Dancing at the Neighborhood Ball . . .**

BELOW: **. . . and the Western Ball.**

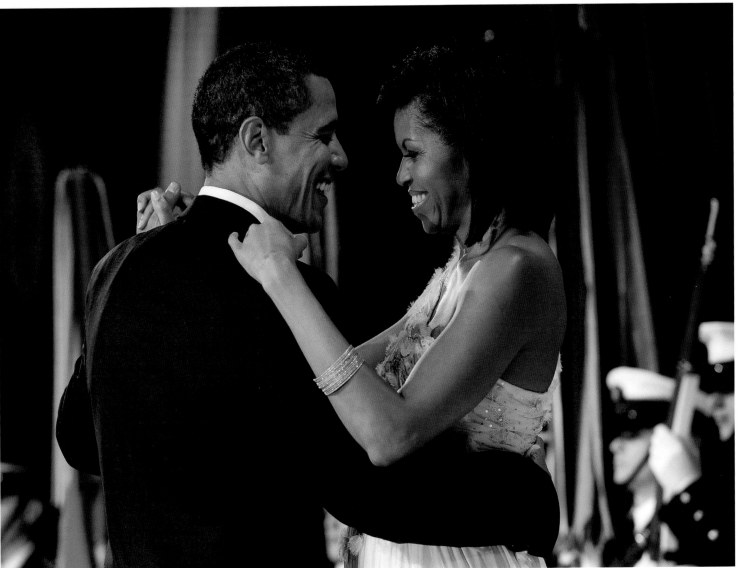

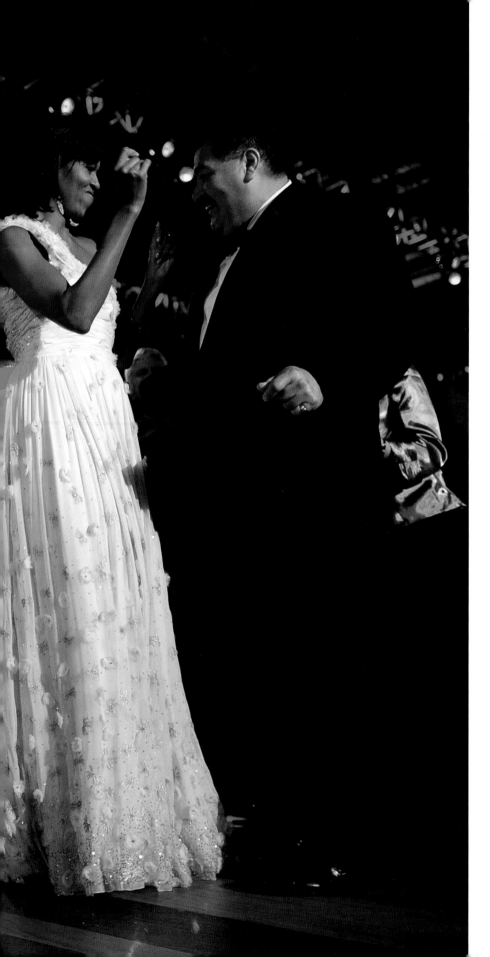

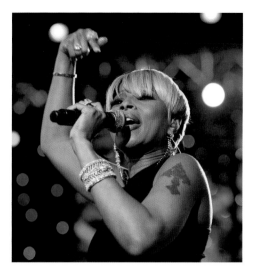

ABOVE: **Mary J. Blige belts it out.**

LEFT: **After first dancing to Beyoncé singing Etta James's "At Last," the president and first lady choose partners from among the party-goers at the Neighborhood Ball for another turn.**

Photos by Richard A. Lipski

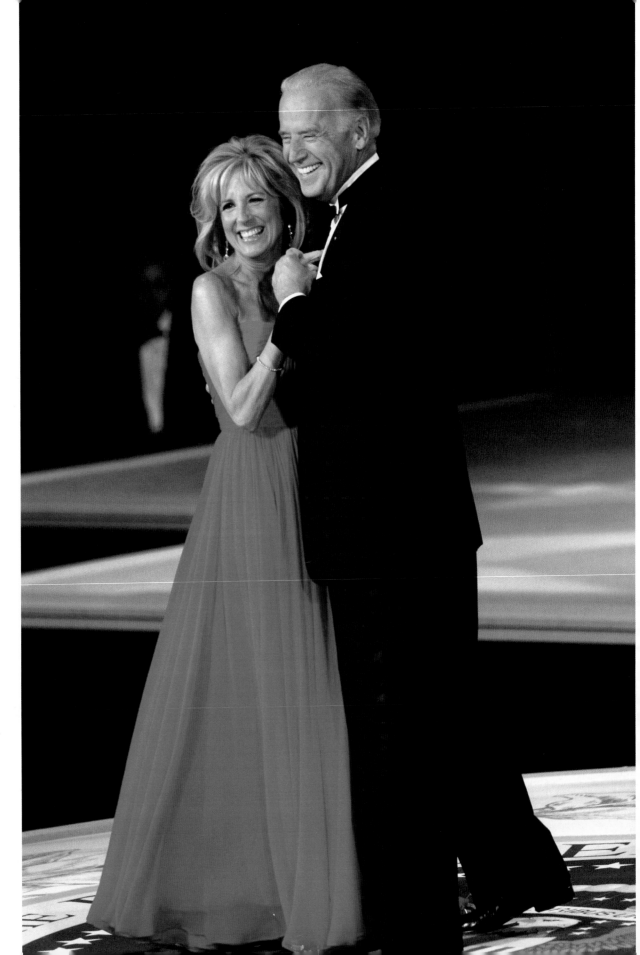

RIGHT: **The Bidens at the Commander-in-Chief's Ball at the National Building Museum.**

OPPOSITE PAGE: **The Midwestern Ball at the Washington Convention Center.**

Right photo by Lois Raimondo; opposite by Debra Lindsey

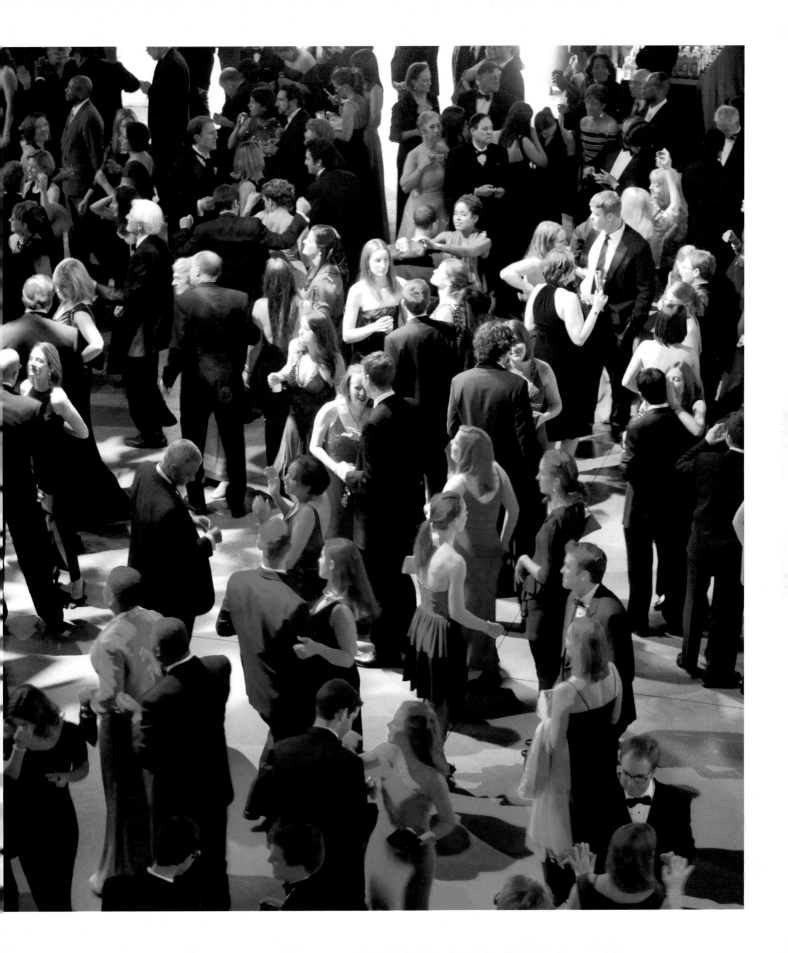

**Amanda Boswell and
Christian Wallace at the
Commander-in-Chief's Ball,
honoring the nation's military,
at the Building Museum.**

Photo by Lois Raimondo

TOP: **Nadine Block, left, and Marianne Rose come to The Art of Change: An Inaugural Ball for Artists, at the Warehouse.**

ABOVE: **Julie Ziff Sint of the group Dance of Fire performs at the artists' ball.**

RIGHT: **John Nader dances with Elizabeth Coleman at the Southern Ball.**

Above photos by Lucian Perkins; right photo by Carol Guzy

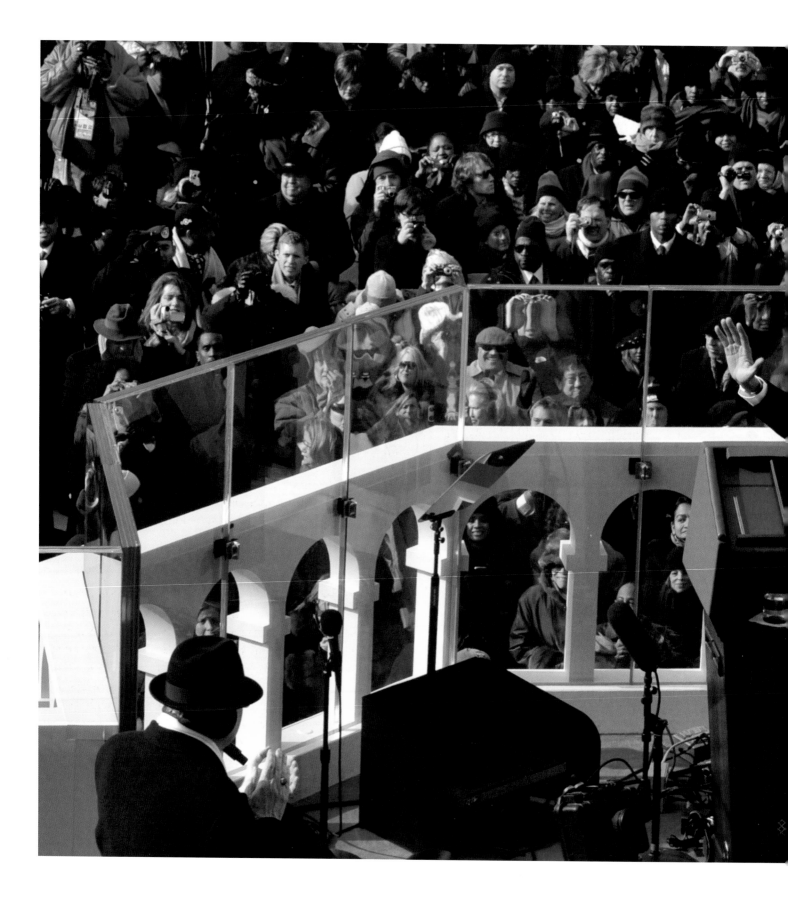

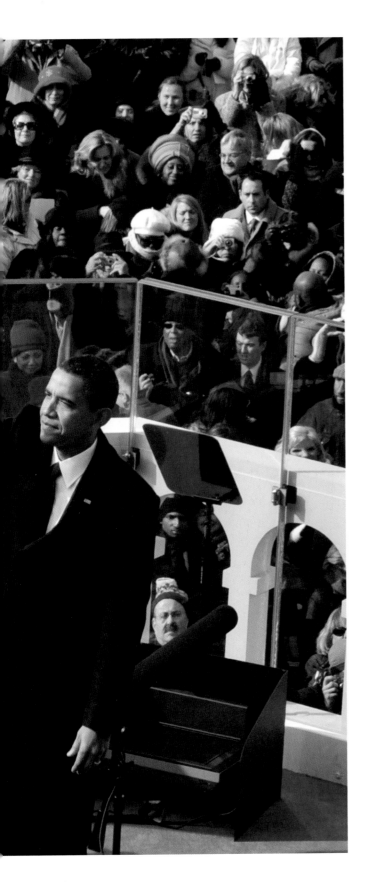

Photo by Bill O'Leary

Inaugural Address

BARACK OBAMA

My fellow citizens: I stand here today humbled by the task before us, grateful for the trust you've bestowed, mindful of the sacrifices borne by our ancestors.

I thank President Bush for his service to our nation — as well as the generosity and cooperation he has shown throughout this transition.

Forty-four Americans have now taken the presidential oath. The words have been spoken during rising tides of prosperity and the still waters of peace. Yet, every so often, the oath is taken amidst gathering clouds and raging storms. At these moments, America has carried on not simply because of the skill or vision of those in high office, but because we, the people, have remained faithful to the ideals of our forebears and true to our founding documents.

So it has been; so it must be with this generation of Americans.

That we are in the midst of crisis is now well understood. Our nation is at war against a far-reaching network of violence and hatred. Our economy is badly weakened, a consequence of greed and irresponsibility on the part of some, but also our collective failure to make hard choices and prepare the nation for a new age. Homes have been lost, jobs shed, businesses shuttered. Our health care is too costly, our schools fail too many — and each day brings further evidence that the ways we use energy strengthen our adversaries and threaten our planet.

These are the indicators of crisis, subject to data and statistics. Less measurable, but no less profound, is a sapping of confidence across our land; a nagging fear that America's decline

is inevitable, that the next generation must lower its sights.

Today I say to you that the challenges we face are real. They are serious and they are many. They will not be met easily or in a short span of time. But know this America: They will be met.

On this day, we gather because we have chosen hope over fear, unity of purpose over conflict and discord. On this day, we come to proclaim an end to the petty grievances and false promises, the recriminations and worn-out dogmas that for far too long have strangled our politics. We remain a young nation. But in the words of Scripture, the time has come to set aside childish things. The time has come to reaffirm our enduring spirit; to choose our better history; to carry forward that precious gift, that noble idea passed on from generation to generation: the God-given promise that all are equal, all are free, and all deserve a chance to pursue their full measure of happiness.

In reaffirming the greatness of our nation we understand that greatness is never a given. It must be earned. Our journey has never been one of shortcuts or settling for less. It has not been the path for the fainthearted, for those that prefer leisure over work, or seek only the pleasures of riches and fame. Rather, it has been the risk-takers, the doers, the makers of things — some celebrated, but more often men and women obscure in their labor — who have carried us up the long rugged path towards prosperity and freedom.

For us, they packed up their few worldly possessions and traveled across oceans in search of a new life. For us, they toiled in sweatshops, and settled the West, endured the lash of the whip, and plowed the hard earth. For us, they fought and died in places like Concord and Gettysburg, Normandy and Khe Sahn.

Time and again these men and women struggled and sacrificed and worked till their hands were raw so that we might live a better life. They saw America as bigger than the sum of our individual ambitions, greater than all the differences of birth or wealth or faction.

This is the journey we continue today. We remain the most prosperous, powerful nation on Earth. Our workers are no less productive than when this crisis began. Our minds are no less inventive, our goods and services no less needed than they were last week, or last month, or last year. Our capacity remains undiminished. But our time of standing pat, of protecting narrow interests and putting off unpleasant decisions — that time has surely passed. Starting today, we must pick ourselves up, dust ourselves off, and begin again the work of remaking America.

For everywhere we look, there is work to be done. The state of our economy calls for action, bold and swift. And we will act, not only to create new jobs, but to lay a new foundation for growth. We will build the roads and bridges, the electric grids and digital lines that feed our commerce and bind us together. We'll restore science to its rightful place, and wield technology's wonders to raise health care's quality and lower its cost. We will harness the sun and the winds and the soil to fuel our cars and run our factories. And we will transform our schools and colleges and universities to meet the demands of a new age. All this we can do. All this we will do.

Now, there are some who question the scale of our ambitions, who suggest that our system cannot tolerate too many big plans. Their memories are short, for they have forgotten what this country has already done, what free men and women can achieve when imagination is joined to common purpose, and necessity to courage. What the cynics fail to understand is that the ground has shifted beneath them, that the stale political arguments that have consumed us for so long no longer apply.

The question we ask today is not whether our government is too big or too small, but whether it works — whether it helps families find jobs at a decent wage, care they can afford, a retirement that is dignified. Where the answer is yes, we intend to move forward. Where the answer is no, programs will end. And those of us who manage the public's dollars will be held to account, to spend wisely, reform bad habits, and do our business in the light of day, because only then can we restore the vital trust between a people and their government.

Nor is the question before us whether the market is a force for good or ill. Its power to generate wealth and expand freedom is unmatched. But this crisis has reminded us that without a watchful eye, the market can spin out of control. The nation cannot prosper long when it favors only the prosperous. The success of our economy has always depended

not just on the size of our gross domestic product, but on the reach of our prosperity, on the ability to extend opportunity to every willing heart — not out of charity, but because it is the surest route to our common good.

As for our common defense, we reject as false the choice between our safety and our ideals. Our Founding Fathers — our Founding Fathers, faced with perils that we can scarcely imagine, drafted a charter to assure the rule of law and the rights of man — a charter expanded by the blood of generations. Those ideals still light the world, and we will not give them up for expedience's sake.

And so, to all the other peoples and governments who are watching today, from the grandest capitals to the small village where my father was born, know that America is a friend of each nation, and every man, woman and child who seeks a future of peace and dignity. And we are ready to lead once more.

Recall that earlier generations faced down fascism and communism not just with missiles and tanks, but with the sturdy alliances and enduring convictions. They understood that our power alone cannot protect us, nor does it entitle us to do as we please. Instead they knew that our power grows through its prudent use; our security emanates from the justness of our cause, the force of our example, the tempering qualities of humility and restraint.

We are the keepers of this legacy. Guided by these principles once more we can meet those new threats that demand even greater effort, even greater cooperation and understanding between nations. We will begin to responsibly leave Iraq to its people and forge a hard-earned peace in Afghanistan. With old friends and former foes, we'll work tirelessly to lessen the nuclear threat, and roll back the specter of a warming planet.

We will not apologize for our way of life, nor will we waver in its defense. And for those who seek to advance their aims by inducing terror and slaughtering innocents, we say to you now that our spirit is stronger and cannot be broken — you cannot outlast us, and we will defeat you.

For we know that our patchwork heritage is a strength, not a weakness. We are a nation of Christians and Muslims, Jews and Hindus, and nonbelievers. We are shaped by every language and culture, drawn from every end of this Earth; and because we have tasted the bitter swill of civil war and segregation, and emerged from that dark chapter stronger and more united, we cannot help but believe that the old hatreds shall someday pass; that the lines of tribe shall soon dissolve; that as the world grows smaller, our common humanity shall reveal itself; and that America must play its role in ushering in a new era of peace.

To the Muslim world, we seek a new way forward, based on mutual interest and mutual respect. To those leaders around the globe who seek to sow conflict, or blame their society's ills on the West, know that your people will judge you on what you can build, not what you destroy.

To those who cling to power through corruption and deceit and the silencing of dissent, know that you are on the wrong side of history, but that we will extend a hand if you are willing to unclench your fist.

To the people of poor nations, we pledge to work alongside you to make your farms flourish and let clean waters flow; to nourish starved bodies and feed hungry minds. And to those nations like ours that enjoy relative plenty, we say we can no longer afford indifference to the suffering outside our borders, nor can we consume the world's resources without regard to effect. For the world has changed, and we must change with it.

As we consider the role that unfolds before us, we remember with humble gratitude those brave Americans who at this very hour patrol far-off deserts and distant mountains. They have something to tell us, just as the fallen heroes who lie in Arlington whisper through the ages.

We honor them not only because they are the guardians of our liberty, but because they embody the spirit of service — a willingness to find meaning in something greater than themselves.

And yet at this moment, a moment that will define a generation, it is precisely this spirit that must inhabit us all. For as much as government can do, and must do, it is ultimately the faith and determination of the American people upon which this nation relies. It is the kindness to take in a stranger when the levees break, the selflessness of workers who would rather cut their hours than see a friend lose their job, which sees us through our darkest hours. It is the firefighter's courage to storm a stairway filled with smoke, but also a parent's willingness to nurture a child, that finally decides our fate.

Our challenges may be new. The instruments with which we meet them may be new. But those values upon which our success depends — honesty and hard work, courage and fair play, tolerance and curiosity, loyalty and patriotism — these things are old. These things are true. They have been the quiet force of progress throughout our history.

What is demanded, then, is a return to these truths. What is required of us now is a new era of responsibility — a recognition on the part of every American that we have duties to ourselves, our nation and the world; duties that we do not grudgingly accept, but rather seize gladly, firm in the knowledge that there is nothing so satisfying to the spirit, so defining of our character than giving our all to a difficult task.

This is the price and the promise of citizenship. This is the source of our confidence — the knowledge that God calls on us to shape an uncertain destiny. This is the meaning of our liberty and our creed, why men and women and children of every race and every faith can join in celebration across this magnificent mall; and why a man whose father less than 60 years ago might not have been served in a local restaurant can now stand before you to take a most sacred oath.

So let us mark this day with remembrance of who we are and how far we have traveled. In the year of America's birth, in the coldest of months, a small band of patriots huddled by dying campfires on the shores of an icy river. The capital was abandoned. The enemy was advancing. The snow was stained with blood. At the moment when the outcome of our revolution was most in doubt, the father of our nation ordered these words to be read to the people:

"Let it be told to the future world . . . that in the depth of winter, when nothing but hope and virtue could survive . . . that the city and the country, alarmed at one common danger, came forth to meet [it]."

America: In the face of our common dangers, in this winter of our hardship, let us remember these timeless words. With hope and virtue, let us brave once more the icy currents, and endure what storms may come. Let it be said by our children's children that when we were tested we refused to let this journey end, that we did not turn back nor did we falter; and with eyes fixed on the horizon and God's grace upon us, we carried forth that great gift of freedom and delivered it safely to future generations.

Thank you. God bless you. And God bless the United States of America.

Kenyans celebrate the inauguration in the home village of Obama's father. *Photo by Jahi Chikwendiu*

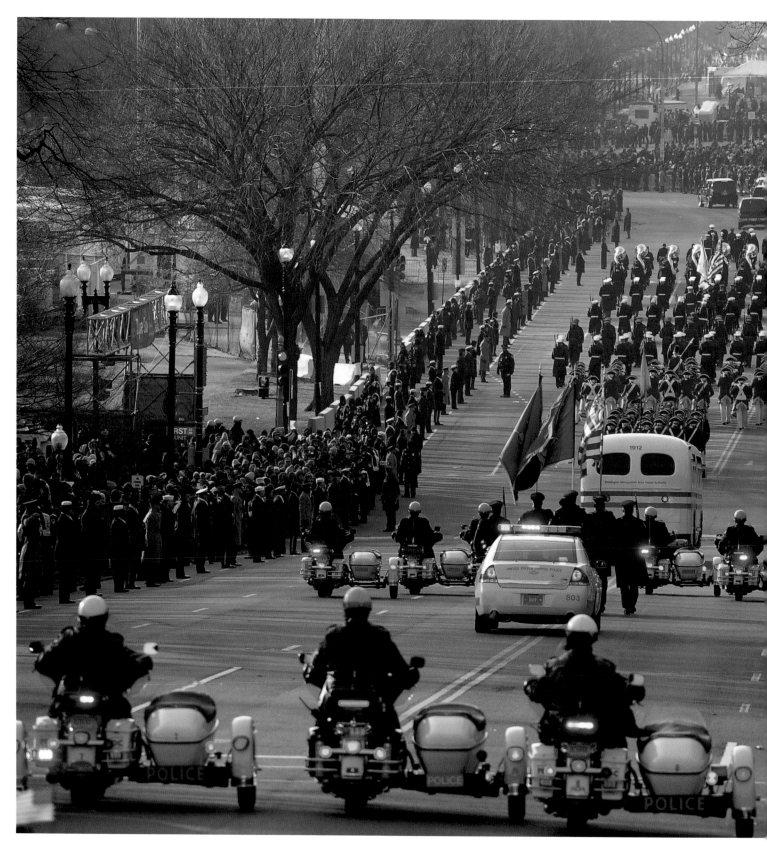

Photo by Preston Keres

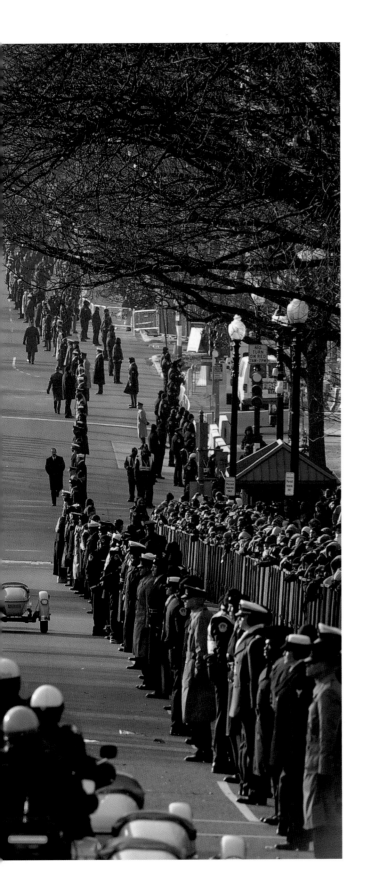

Afterword

"The presidency alone invites the conjectures of the public."
— *James Madison, 1788*

They came from across the land, by air, by rail, by road and on foot. They filled hotels and stayed with friends. They arrived amid the temples to American democracy before dawn and even before the dusk that preceded the dawn.

The crowds that gathered in Washington to witness the inauguration of America's 44th president, Barack Obama, were among the largest the country has ever seen. When they reached their apex, just before noon, just before the new president took his oath, roughly 1.8 million people were assembled on a clear, cold winter day to witness the installation of the first African American president in the nation's history.

From the start, America's presidency has been a political and popular preoccupation. The Founding Fathers agonized over how much power they should invest in the office; the people of the new nation clamored for a popular leader, Gen. George Washington. Over the years, the presidency has become the country's locus of power and the living emblem of the United States in the world.

For The Washington Post, coverage of a great metropolis and the national government and rituals of democracy have been closely intertwined since our founding in 1877. "We will do what we can to . . . increase the conditions most favorable to the success and prosperity of our institutions by preaching sound Democracy," The Post's editors said in the paper's first edition.

The photographs here capture a moment in history unique for what it was — the inauguration of an immensely popular young new president, and what it represented — "a giant step on a long path to overcoming the stain of slavery and discrimination," as The Post's editorial page put it.

These images are a tribute to the people who came, who saw and who participated in that moment, and a testament to the durability of the American democratic experiment.

— *MARCUS BRAUCHLI, Washington Post Executive Editor*

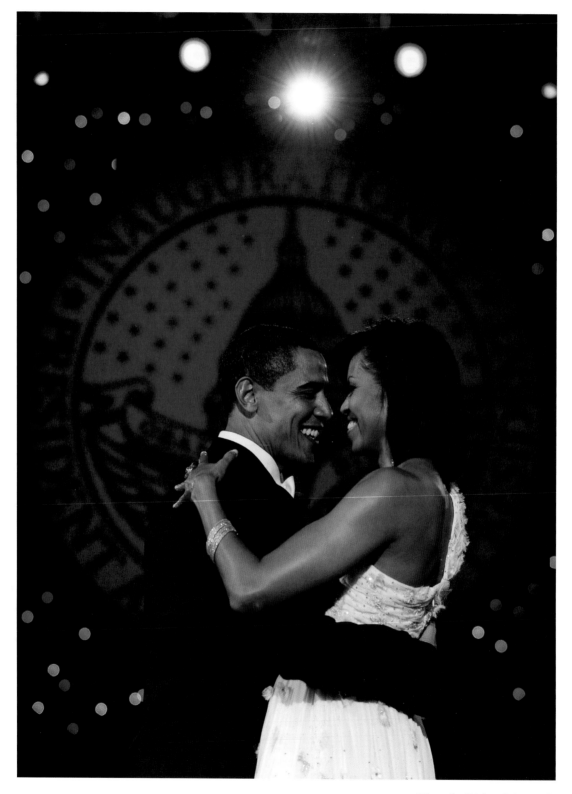

Photo by Richard A. Lipski